How to Talk to CHILDREN ? ABOUT MODERN ART

To Yoram
For Emmanuel, Éden and Raphaël

My thanks must go to Brigitte Stephan, Director at Le baron perché who encouraged me to write this book and to Céline Ottenwaelter for her commitment and efficiency in seeing this project through. It is only fair that I also mention all the children, teachers, parents and grandparents who told me how much they enjoyed *How to Talk to Children about Art*. Their feedback encouraged me to continue. I hope that this new book will allow them to make some more discoveries. And also a big thank you to my children and to the first person I showed this to, my husband.

How to Talk to Children about Modern Art

Originally published in France as
Comment parler de l'art du xxᵉ siècle aux enfants: De l'art moderne à l'art contemporain
by Le baron perché 2011

First published in the English language by
Frances Lincoln Limited
4 Torriano Mews
Torriano Avenue
London NW5 2RZ
www.franceslincoln.com

Translation by Phoebe Dunn
copyright © Frances Lincoln Limited 2012

A catalogue record for this book is available from the British Library.

978-0-7112-3289-1

Printed and bound in China

1 2 3 4 5 6 7 8 9

AUG 0 3 2012

How to ? Talk to CHILDREN

ABOUT

MODERN ART

Françoise Barbe-Gall

F

FRANCES LINCOLN LIMITED

PUBLISHERS

CONTENTS

FOREWORD

This book is aimed at anyone interested in modern art who wants to go beyond first impressions and share their discoveries with their children. It's a book in its own right but follows on from *How to Talk to Children about Art* which had the same aim but took a historical perspective.

Museum visitors of any age regularly ask themselves the most straightforward and legitimate of questions, questions which simply can't be answered by any amount of technical knowledge. So the aim of this book is to help bring some clarity, to help the viewer understand, step by step, what they are seeing. It is definitely *not* a simplified art history textbook, neither is it a summary of the main movements of twentieth-century art or the theories that accompanied them. It uses everyday language: exactly the language that inspired modern art, because it connects directly with reality.

Speaking about art with children is not necessarily straightforward and the often disconcerting appearance of modern art can make it seem all the more complicated. How best to share something you may only partially understand yourself and about which, let's be honest, you may have mixed feelings? But rest assured it takes neither a huge amount of knowledge, nor a huge amount of effort. Often all you have to do to get started is to put aside your preconceived ideas and trust the artists in question. And anyway, the child's perspective will really help, since for them art that speaks directly to the emotions will seem quite natural. Once you have put aside your preconceptions the ideas will flow more easily than you may imagine.

The first two sections of the book deal with general ideas around the content and the materials used in modern art, but focus above all on opening up a number of routes that will make the works more accessible. You'll notice that often a simple shift in perspective is more effective than any learned discourse.

The pages in the third section of this book are like mini-visits to the featured works of art and they take the form of a conversation rather than a commentary. The comments or remarks may belong to children or adults and the text follows a progression based on three age-groups from primary school children to adolescents and beyond, allowing you to move from first impressions to more symbolic or historical considerations. It's presented as though you begin looking at the image at five years old and gradually grow up while you are looking.

We might quite rightly be criticized for not including any photography nor for

including an introduction to video art. But within the limits of this small volume we only had space to deal with a few works and one or two samples would not have done justice to these specific fields that are so very rich in their own right. So it seemed preferable to focus here on the works of painters and sculptors. Other modern and contemporary artists were covered in *How to Talk to Children about Art*: Marc Chagall, Fernand Léger, Piet Mondrian, Jackson Pollock, Yves Klein, Jean-Michel Basquiat, Francis Bacon and Georg Baselitz. For simplicity, references to these artists are made by citing *How to Talk to Children about Art* and the work number. The book also includes names of artists and works that may be of interest beyond what is covered here.

One basic aim was to light as clear a path as possible from modern to contemporary art, so we have given proportionally more emphasis to works from the second half of the twentieth century. Of course the choices we have made are imperfect and might well provoke discussion but they are founded on two desires: firstly to deal with famous works that are hard to access and secondly to show how they fit into the history of art itself. We hope that if we have been successful this will lead to a greater and happier understanding of art today.

START ON THE RIGHT FOOT

Getting to grips with the problem

It's quite normal to feel all at sea when you're standing in front of a piece of modern art. Struggling to make any kind of connection with anything at all familiar can make you feel really rather stupid. And just *thinking* about the effort involved in getting to grips with what you're seeing can be demoralizing – so you end up doubting not only yourself but the point of the piece in question. Being puzzled can get you bogged down, so the thing to do is to turn that puzzlement around and think of it as a great place to start. It proves that something has had an effect on you – even if you don't necessarily understand it. And that is precisely what is going on in a lot of contemporary art, which plays directly on the sensations it creates without getting hung up on 'knowledge'. Once you've faced your bewilderment head-on you've taken the most important step.

The reality of prejudice

Quite apart from the works themselves, what makes things additionally complicated is the mass of prejudices and clichés that come to the fore when it's a question of modern art. Whether you're aware of it or not, even the most open-minded of us brings a whole load of preconceived and unhelpful ideas that disguise themselves as 'thought' but actually stop us from thinking freely. This is less the case with ancient or traditional art. No matter how much or how little you know, or how appealing something is, it's generally the case that we somehow *believe* in traditional art more easily; the workmanship, the lofty subjects, the authority and prestige of the centuries mean we more readily trust what we are seeing. So there is a tendency to approach modern art from the perspective of what it *isn't* – that is to say, it's not 'traditional' or 'historical' art. Rather than glossing over this perspective as though it were not a legitimate reaction but the kind of basic error only a beginner would commit, let's make the most of it. That negative point of view can actually be very helpful if you think about where it comes from, which doesn't take much effort. And it's certainly preferable to check that you'll be able to share something more than your prejudices before you embark on the adventure with a child.

The abandonment of Beauty

One of the accusations most frequently levelled at modern art is that it has given up on Beauty. And, if you apply traditional aesthetic criteria that prize harmony, grace and beauty, it may often be true. But even if your definition of Beauty does not assume that it is finite, fixed and best demonstrated by the works of classicism you may still struggle to appreciate works that seem to deliberately ignore it.

For centuries art's aim was the creation of Beauty. The Church used art to express divine perfection. In all those religious images, which today fill museums and art galleries, the viewer was meant to see excellence, purity, nobility, calm and an idea of saintliness which would have stood in contrast to the poverty and affliction of the real world. But modern art often fails to offer us any of those things, precisely because its aim – and so its means of expression – has changed. For those of us steeped in the neo-Platonic Renaissance view that Beauty equals Goodness and Truth, it's a huge stretch.

Modern art doesn't propose either a spiritual or intellectual ideal (or both), it contents itself with real life – with life as we live it, with life, full stop. Goodness was seriously wounded by two World Wars so it's no longer an all-powerful reality and Beauty has crumbled along with it. In its disillusionment modern art turned its focus to even the smallest aspects of life – as long as they were truthful.

So whenever you find yourself in front of a piece of art that seems less than graceful or elegant or that seems to lack what we have come to see as real aesthetic quality, you are likely to be able to discern at least an attempt, a hope or even sometimes a wild desire to speak the truth. And that truth may entail all sorts of detail, approximation and ugliness but may also contain some hidden, surprising or stealthy beauty. That's sometimes all that's left – and it's hugely significant. It means that the man on the street can finally see himself in art's mirror without feeling judged by it. Twentieth-century art forgives us our imperfections and says we are just as much the children of the Elephant Man as of Apollo.

The fear of despair

The connection between Goodness and Beauty also meant a connection between Beauty and bounty (or Virtue). Ugliness inevitably became synonymous with evil. The same principle applies in many of today's adventure films – the ugly guy is likely to be the villain to be treated with suspicion. When a work is what we have come to accept as 'ugly' we are quick to find it 'aggressive', 'dangerous', or worse 'despairing'. But that's forgetting that modern art, by virtue of its very existence, is the very opposite of despairing. It tears itself away from despair and sets itself in opposition to despair in everything it does. It may still bear some scars – a source of sadness, a faraway look – but it was built on fighting terrors. Mistaking art for one of those terrors is to confuse it with the very thing that art is denouncing. Though many modern pieces may seem terrible to look at they always represent a defeat to humanity's dark side.

The difficulty of understanding

People generally think that traditional or historical paintings are easier to understand than modern ones. In fact when we find ourselves in front of a painting whose subject we don't understand – unless we happen to have a thorough knowledge of the Bible, mythology and history at our fingertips – then we end up defaulting to admiring the composition, the drawing, the light on the landscape or an expression on a face, the richness of the detail. And then we seem to realize that often we are doing no more than decoding what we see: a woman, a forest, soldiers in armour. But that means we are confusing readability with ease of understanding. Twentieth-century art, which initially appears harder to read, is actually easier to understand because it deals with themes we all share. The great novelty is that it deals with those themes whilst also posing questions about them. It's that questioning or critical dimension which gets between us and the work. Take for example a Cubist portrait painted by Braque or Picasso around 1910. It doesn't describe a man sitting down *photographically* but it takes into account what that man himself will be feeling. The parts of his body that are in contact with his surroundings are shown in the painting as segments of lines, geometric signs or smudges of colour. By using these methods the painting creates something fundamentally much closer to reality than say, the *Mona Lisa*.

The suspicion of elitism

Sometimes the idea that art might have more of a motive than simply providing pleasant decoration can cause an extreme reaction – as though the artist's thought process automatically put the work beyond a layman's understanding. That sense of exclusion is all the more prevalent around a certain kind of discourse about art in general – all the more so because owning the pieces themselves, as opposed to understanding them, is only within reach of a very few. At that point there should be no hesitation. A text which doesn't enlighten should be rejected straight away. At a museum or gallery you can feel foolish that you don't understand it all. But why? Would you be embarrassed to go on holiday in the mountains without first having studied geology or the history of sledging? Accusing art of being 'intellectual' is a triple injustice. Firstly it's an injustice to the word itself, because the word 'intellectual' simply refers to mental activity. Secondly it's an injustice to the artist who is unlikely to have been working with only historians and critics in mind. And thirdly we do ourselves an injustice if we immediately avoid true meanings. Art will always express thoughts about the world – but now it will do so in a direct way – in shapes, images and colours that everyone can broadly grasp. The elitism art is accused of was certainly real in centuries gone by but is now just the pretext for poor process.

The pleasure of finding an old work 'very modern'

Without realizing it today's viewers – with a lack of reference points and with preconceived ideas about contemporary art – often appreciate it in a rather inside-out fashion. When we say a piece of traditional art is 'very modern' it can be with as much surprise as pleasure. It's because we recognize a certain style in the use of space or a simplicity in the shapes that we are already familiar with from twentieth-century art. But it would be just as possible for us to appreciate modern art without traditional art acting as a kind of primer and to realize that style and simplicity are eternal qualities simply highlighted by being front and centre in modern art. Which of course implies that traditional art is not so much 'modern' when it suits but that modern art is in fact more 'ancient' than we think.

Discovering other perspectives

It's difficult to speak convincingly about something you're not convinced of yourself. So before tackling a piece of modern art with a child it is best to allow yourself time to get comfortable with it. There are all sorts of ways of doing this and the methods outlined below should be more or less feasible depending on your own way of thinking. You don't have to follow all of them – even though one may naturally lead to another and from there on to another still. The important thing at the beginning is to make your own way before bringing someone else along with you. And you may well find that children can quite naturally appreciate pieces that we adults find more demanding.

Forget about labels

We enjoy looking at flowers without knowing what they are called, let alone their Latin names. And it is best to approach a work of art in the same way. Forcing yourself to learn the chronology of the different movements and styles and then 'illustrating' them with examples is a fine intellectual exercise for school but it's a very limited way of appreciating art. There's no point in getting frustrated if you can't master the facts and figures – artists themselves didn't like being labelled and put into restrictive categories. It's far preferable to have an immediate and sensitive response to a piece of art that's founded on really looking at what's in front of you. It's a kind of simple but challenging immersion.

Feel the 'mechanics' of a piece

The term 'mechanics' was used by Henri Matisse in referring to painting but it can apply equally well to any kind of art. The key is to come to art without any expectations and to allow yourself to be carried away by what the artist has put into it. If you are able to resist going straight to the exhibition notes before properly looking at the piece of art that's even better! When we are first introduced to someone do we ask to see ID? No, we are quite used to finding out the details later. At the beginning it's much more enriching and revealing to be conscious of the sensations we have in front of a painting or another piece of art than to be full of academic knowledge about it.

Put your own reactions into perspective

Whilst it's good to value your own personal response to a piece of art, you will need to go beyond that too. Our reactions are often variations on a theme of 'I like it' or 'I don't like it' but they should really just serve as a jumping off point. 'I like it, but why do I like it?' Something about it has triggered a reaction and getting to grips with what that something may be the key to the piece's meaning. Then again, our reactions can change, not only over time but depending on context. You might be struck at first by a window painted in 1912 by Delaunay, but then half an hour later think it's the most traditional thing in the world – if in the meantime you've been looking a Mondrian! But you also have to choose your moment for engaging with modern art. It's best not to force yourself to stare at something you just 'don't get', but instead leave it and go back to it another time. It might take years, or you may simply never 'get it' but that doesn't matter. There are so many more things to see.

Focus on connections

We often think of traditional art and modern art as two separate worlds divided by an impenetrable wall. But it's always more fruitful to focus on the intellectual and formal *connections* between the centuries. Certain very old works of art may still make a direct connection with modern-day artists and for us viewers, despite their history. On the other hand the vision of reality that modern art offers us is absolutely connected to all the visions of reality that have preceded it. It might simply respond to them, or contradict them, it might batter them, support them or mock them, but it never ignores them. So as viewers we are just as capable of being receptive to an abstract work painted by Tàpies as to the details of a Murillo painted three centuries earlier. We will be stunned to find that both artists were inspired by the elemental simplicity of their materials reminding us that man came from the earth and will eventually return to it. The same can be said of the vast black breaths of Soulage – a foretaste of which can be glimpsed in the shimmering light of some Reubens portraits. It doesn't take as much knowledge as we might think to find those connections. All you need to do is allow yourself freedom to *see*. It can be a truly fruitful approach if it allows you to make those connections without getting tied up in scholarly conventions.

Forget the figurative/abstract distinction

The birth of abstract art took place around 1912 with the work of Kandinsky (1866–1944). The century that followed was then filled with abstraction in all its forms: expressionist, lyrical, geometric and so on. Even if it's useful to understand abstraction's origins from an academic perspective we must stress that for many artists the distinction between figurative and abstract has now lost any meaning. Above all, that distinction has the major drawback of focusing on whether or not reality was given precedence in a picture rather than appreciating the activity of painting in and of itself. What's more, from the viewer's point of view the quite natural question of 'What does it represent?' can itself be a stumbling block. Even assuming they can answer it, the viewer may then feel obliged to look further – or in other words they may confuse the *meaning* of a painting with its *subject matter*. If you abandon that distinction (which isn't always black and white anyway) from the outset you quickly realize that since the eloquence of a work can't be reduced to the story it's telling you have a much deeper artistic sensibility than you thought.

Don't limit young children to the abstract

People often think that young childrens' painting is 'abstract' so they fall into the trap of only showing them abstract art, thinking that they will be able to relate to it more easily. It leads to confusion: focusing on technical similarities or what you take to be technical similarities only puts off the all too easily dismissed question of 'What does it represent?' replacing it instead with 'How is it made?' It's true that this is one way to introduce the littlest ones to a dazzling array of inspirations (different use of colour, material, collections of objects) but that can't take the place of discovering the works themselves – always based on a particular idea and always in relation to history. Cutting up paper 'like Matisse' is fun but it's a shame to think that throwing some paint at a canvas or having a hole pierced through it could be a sufficient introduction to the work of Pollock or Fontana. No matter what you chose to show to children you must remember that the artist's technique – often more sophisticated than it seems – is a means of expression and not an end in itself.

Trust the artist

The suspicion that an artwork was easy to create does tend to colour how we look at modern art: plenty of pieces are reduced to being seen as deliberately provocative, or at least as making a playful gesture. But that is again to confuse the means with the end. When Magritte painted a pipe and wrote underneath it 'This is not a pipe' it wasn't just for the pleasure of making a good joke. He's actually telling the truth: this isn't a pipe, it's a *picture* of a pipe – if it were a pipe you'd be able to smoke it! By using humour he reminds the viewer of the insuperable gulf between the object and its representation. This is typical of modern art – and not only of Surrealism which consistently made that point. Even if you are looking at a 'raw' object (like a Duchamp 'ready-made') then it's still a question of a representation of the object. So the work always signifies more than the object it describes because it constitutes a version 'augmented' by the mind and the sensibility of the artist.

Finding your own connections

Modern art is *not* cut off from what came before it, and neither is it disconnected from the world that surrounds it. To get started you can always begin chronologically and focus on pieces from the same period. The aim is not to pile up knowledge but to get your bearings by making the connection between a piece that disconcerts and the things that you can already relate to yourself. For some that will be a connection with the development of technique, for others the date will connect to a significant point in political history, a famous film or a play. Everyone calls upon their own network of references. One of the simplest examples comes from literature. If you remain unmoved by Sam Francis's work (work 12) you might see it differently after reading Melville's *Moby Dick*. You might feel disorientated in front of an installation by Christian Boltanski (work 25) and not feel like taking time to look at it, but then you may recall the role that photographs play in the work of Patrick Modiano and remember the powerful emotions they evoke. Each viewer brings with them a huge array of internal and external references, which together with the works in the museum set off a whole system of echoes. It's just the same for children who have a whole visual repertoire in their heads (see work 27) that it would be a shame to neglect.

Seeeing the bigger picture

Most of the time we only recognize a few works by a certain artist – usually the ones that have been most frequently reproduced, perhaps because they are the most representative of their achievements throughout their whole career. Exhibitions and particularly retrospectives offer a chance to better appreciate the artist's oeuvre as a whole. Firstly they enable you to see the logical evolution of a theme as it developed over time but also, and mainly because they make it very clear, how inextricably linked the work is with the life of the artist. That is not so much because the work illustrates the life but because that is its source of legitimacy: what might seem insignificant or negligible from a technical or material value perspective (see work 20) could take on a whole different appearance when seen in light of a whole life. Very often the doubts that we feel when faced with a piece of modern art simply evaporate when you discover in it the truth of the existence that underpins it. So it's always worth widening your perspective.

Go to museums

It seems obvious but it's not always straightforward. There are innumerable reasons not to go to museums: we're busy, we're put off by their poshness, nice weather beckons us away or rain makes us want to stay at home, it's too far, or so close we could easily go another day, there are so many pieces to see, or too few, the exhibition has already finished, it's tricky with children . . . But it really is best to see art for real rather than relying on books. Books are essential for building our knowledge and they can help us think about what we have seen by providing a useful aide-memoire but they cannot take the place of directly looking at a piece of art. We know that any reproduction – no matter how high the quality – can never fully do justice to the work. For modern art, there's something else: the relationship with the exhibition space is as significant as the work itself. Finding yourself in front of a collection of neons by Dan Flavin is an experience that no photograph can convey, no more than it can show you the power of a Maurizio Cattelan (work 29) installation. In the end, photographic reproductions impoverish modern art more than they serve it. So it's essential to seize every chance that you can to go and see the works first hand.

Notice the museum space

Museums are no longer places where works are simply displayed in long lines. In exhibitions and permanent collections of modern art these days a lot of emphasis is given to how the works are presented together (the museography) in a way that plays on the resonances of the works and sets up natural paths of discovery. Museum or exhibit maps – or just paying attention to layout – can be invaluable for getting the most out of a 'window-shopping' trip to see modern art. Certain pieces by different artists displayed in different rooms may play off one another and establish a kind of mirroring game of contradictions and connections which goes beyond mere chronology, the sizes of the rooms or the level of lighting from one area to another. Looking at art becomes all the more rewarding once you are tuned in to these aspects of an exhibit. It's also worth bearing in mind how a piece's meaning can become clearer depending on where one is standing and how far away. But that's not to say that a visit should become some kind of war of attrition, the key is simply to use your capacity for observation all the more.

Enjoy your age

Art travels light these days. It had accumulated all sorts of memories and baggage but modern art has gradually shed them. As viewers we are used to the technical richness of older art so we might have some difficulty with certain modern pieces being so stripped back (see work 18), giving rise to the oft-expressed feeling that 'No doubt you have to be young to like this kind of thing'. It's true in one sense because children are capable of imagining a world in something as simple as a cardboard box or a piece of string – displaying the same sort of creative freedom as modern artists. But in another sense it couldn't be further from the truth. Contemporary art often relies on a powerful emotional charge in which older generations can also recognize the weight of a shared experience. More than any kind of art that has gone before it, modern art unites sensibilities and different levels of understanding which may apparently have little in common. Because, if it helps to be young to let your imagination take flight before a tiny mountain of pollen (work 20), then being a little older will also allow you to see in that same mountain the intrinsic value in a single, minuscule grain of life.

IT'S OK NOT TO KNOW EVERYTHING

Modern and contemporary art

Two eras

Modern art began at the turn of the twentieth century with the era of Fauvism and the early works of Cubism: 1905 saw the beginning of the Fauves, a movement which included Matisse, Derain and Vlaminck, in the autumn Salon. In 1907 Picasso created *Les Demoiselles d'Avignon* – a painting which for the first time presented a view of the world (specifically a nude) like a shattered mirror.

It was the eve of the First World War, at the beginning of which the most spectacular aesthetic revolutions took place. The Dada movement that was started by young writers and poets in Switzerland exploded the tradition of images inspired by Western humanism – the horror of war meant those traditions were no longer valid. A few years later the Surrealists continued the process by prizing the Subconscious over Reason, whose laws were no longer worthy of respect. From then on the dreams of any single individual – no matter who – could hold more meaning than history itself. In 1912 Kandinsky declared the supremacy of the 'interior necessity' and invented abstract painting, which for the first time did not in any way attempt to imitate reality.

After the Second World War it was the material concept of the work itself that was revolutionized. Artists were no longer limited to traditional modes of expression or materials and started to branch out into new areas, including using images and objects from daily life. These different approaches developed in parallel and sometimes combined within a single work. And sometimes a certain nostalgia for bygone centuries itself became an element of the creative process, contributing to a classical-style harmony (see work 9).

Contemporary art is created by artists who are effectively our contemporaries. But the term is also used to refer to pieces that opened completely new creative avenues – from the 1960s or even the 1980s. Visitors to museums will notice that the distinction between modern and contemporary varies slightly from institution to institution. That's just because the term 'contemporary' moves with us through the years.

It might be worth reminding children that 'modern' art has nothing to do with what history books call 'the modern period' – a much longer era lasting from 1492 to 1815.

Historical context

Artists don't work in ivory towers. They are surrounded by the real world and the real world inspires their work – art is a distillation of life. Although a detailed knowledge of twentieth-century history is not a prerequisite to appreciate modern art, it's helpful to have in mind key historical episodes because their impact on art is too significant to ignore: from the unprecedented exploration of psychoanalysis to the horrors of two World Wars, the century sounded the depths of utter destruction and its images quite simply did the same. Likewise, the awareness of empty nothingness and all its associations is present in plenty of works – absence, debris, brokenness and so on are all direct echoes of the atomic explosion. After Hiroshima man's relationship with the world would never be the same again and art reflects that. There was no need for artists to put it down in writing, their choice of form – or rather the lack of form – speaks for itself, in tones of derision, tragedy or even by retreating into private contemplation.

Art in society

In medieval churches paintings told people what they needed to know and to believe in. Between the hope of heaven and the fear of hell images represented a place of certainty. By virtue of its rarity, but also of its pre-eminence over the written word which was originally highly inaccessible, art became the designated domain of spirituality. In the salons of the seventeenth and eighteenth centuries, which shunned the sacred, art came to represent the highest intellectual values before it turned its attention to daily life during the Impressionist era. Over the centuries painting and sculpture gradually lost ground as other modes of expression – writing, photography, cinema and video – came into their own. But by absorbing new techniques and shifting its point of view art only came to increase its impact. From the twentieth century onwards art was able to deal with any subject in any way imaginable. Art began to ask questions, to manhandle or play with the day-to-day: the key was that henceforth no subject matter would be unworthy of the artist's attention. Twentieth-century art is omnivorous and our surprise as viewers before pieces which have little obvious connection to what had previously been known as 'art' comes from that fact. Art itself needed to be removed from the exclusive and aristocratic world of tradition and to work on a new level by truly embracing reality.

What is twentieth-century art about?

Modern art is about the things that art has always been about: life, death, time and man's relationship with the world around him. But with modern art there are no longer any of the traditional distinctions between genres which had created a hierarchy between portraits, historical painting, landscapes and still lifes (see *How to Talk to Children about Art*, pages 46–55). While those subjects can still be found in modern art they are no longer valid categories in and of themselves. Whether or not you see a picture of a landscape, a face or pure geometric patterns, humanity is ever present as the true subject of modern art. Modern art puts humanity itself directly under the microscope, occasionally doing so with shocking brutality. We may be struck by the ravages of age depicted in a Goya painting but we are also enchanted by the miraculous lightness of his brushstrokes. With a Lucian Freud portrait on the other hand, each brushstroke heavily scratches out the features, disconcerting the viewer who feels somehow overcome by the weight of reality. Nothing can distract or console us from that.

Emotions

At the end of the nineteenth century Van Gogh and Edvard Munch transposed their emotions into colour. No one had ever seen such a distorted church as *L'Eglise d'Auvers* nor such a ghostly face as the one in *The Scream* but everyone understands them as projections by the artist. It was just the same with the Expressionists at the beginning of the twentieth century and the trend has continued to amplify down the generations. Sometimes the subjectivity of a feeling is quite enough to build a work of art on. In the exaltation of a line or geometric shape beautifully executed we can read an immediate expression of what has been lived. Rather than seeing someone scream, for example, you see the paint seeming to vibrate on the canvas. In a nineteenth-century painting you might see a woman crying, whereas in a twentieth-century one you might see the stains, the grey marks in place of her tears. If the work is disconcerting that may be because there are none of the people, situations or places that we typically associate with emotions. The work takes a shortcut to expressing fear, joy, suffering, loneliness, anger, revulsion or pain. And by doing so it allows the viewer to see something of their own emotions as it were, un-witnessed.

Everyday life

In the vast majority of cases modern art deals with subjects from everyday life. On the one hand that is because it generally prefers emotions to learning, and on the other, since Impressionism the traditional narrative subjects (which required some kind of literary insight) have given way to new subjects; relationships between people, behaviour and the 'landscape' of daily life.

And yet, stories still play a kind of catalyst role – capable of setting off a series of thoughts. Depending on the artist's era it may be a question either of complicity or of critical distance from the theme, but what remains central is the common experience it highlights. A Cubist still life by Braque, a Mondrian with its simple black quadrangles on a white background, the life-size resin *Tourist* by Duane Hanson, *Poubelle* ('bin') by Arman all 'speak' if not initially *to* us all then at least *about* us all. Braque caresses the form of objects we all see every day, Mondrian sets up the ideal outline of a space for living, Hanson passes by his summer neighbours noticing their every detail from head to toe as we sometimes shamelessly do, Arman collects and assembles rubbish that could be our very own, showing an urgency to make art from it before we start drowning in it. These are just a few examples from across the twentieth century that show just how consistently artists have worked in a way that's both immediate and full of life and how in that way they have closed the inherent gap with classical themes.

Contemporary history

Some artists in the first half of the twentieth century, like Otto Dix for example, took a descriptive approach to contemporary history. *Metropolis* (1928) and *War* (1929) focus on certain elements in order to accentuate the expression. In *Guernica* Picasso had already stripped out any direct references; the action is quite divorced from any identifiable context and none of the characters are recognizable – which was immediately held against him. But if he failed to chronicle history he certainly didn't intend to diminish the meaning of the event – on the contrary he wanted to highlight its symbolic value. Of course it is a unique work but it indicates a significant mindset: pictures were moving further and further away from storytelling and substituting characters with evocative figures.

Fifty years later the ravages of the Second World War appear like great gashes in Alselm Kiefer's enormous landscapes. These are not the scenes of any specific

action but spaces that have been scourged and shredded, overflowing with names in disarray, fruitless furrows weighed down by muddy colours. The canvas has no tale to tell because it too is a battlefield – the artist uses his materials to embody history.

Myths

The gods and heroes of mythology still feature in modern artists' repertoires but in a new way. The details of their adventures and their characters are no longer the core subject matter but now feature among a number of motifs from which artist are free to choose. Nevertheless the principles they embody – hope, beauty, savagery, guilt, purity, vengeance, distraction, folly and so on – have found a new lease of life in modern art. In the past it was possible to find several different interpretations of a single character by different artists (Venus for example in the sixteenth century or the Muses in the seventeenth century). Now it's more a question of a general contemplation in which each artist represents a point of view. Using the great myths whose heritage is clearly evoked in the titles of some modern pieces, artists sought above all to (re)construct an image of man by referring to classical tales. The Muse (Brancusi), the Minotaur (Picasso), the Erinyes – vengeful deities (Francis Bacon), Pasiphaë (Jackson Pollock), Bacchus (Cy Twombly), Iphigenia (Joseph Beuys) are a few examples of those recurrent characters which eternally play out humanity's destiny. These modern artists found a way to transcend the old stories, to strip them of their magic and re-examine their foundations.

Nature

All the medieval painter needed by way of décor for his scenes were some stylized hills and outlines of trees. And in the seventeenth century it was possible to compose a whole anthology about the carefully selected elements that would appear in paintings – streams, woods, mountains, skies, bridges, roads and so on. Painting brought order to natural chaos.

During the nineteenth century artists saw in nature a reflection of their own souls and so tended towards spectacular scenery – sunsets, storms and shipwrecks – before turning their attention to the more concrete realities surrounding them; a little path, a group of trees bordering a garden and so on.

Landscape's ambitions faded over time – the views extended less and less far, depicted fewer and fewer things but showed them with a growing attention to detail. In the twentieth century artists looked at the real ground beneath their feet (Richard Long), tree bark they could touch (Guiseppe Penone), bundles of sticks (Mario Merz), a few blocks of stone (Joseph Beuys), or a collection of pollen (Wolfgang Laïb). They would paint or sculpt their appearance sometimes taking items directly from nature or, in the case of Land Art choosing to work out of doors – far from towns and museum crowds. From one perspective this development might be said to lend landscape a dignity it was never allowed when it was merely a backdrop but it also allows us to filter our vision of nature through an awareness that much of our environment is endangered. The natural world is under threat today and so is all the more present in art; not so much as representation but as a subject to feel, touch and save.

Most of the time the concept of a landscape involves some sort of reference to the elements and earth, fire, water and air play a major role in many works of modern art. That in itself represents a return to source as the elements have always symbolized the very conditions for life itself. The forces of nature in harmony with one another, gravity exerting its pull, fire devouring a canvas: artists have explored all the elements from every angle. And the poetic angles are the subject of Gaston Bachelard's contemplations in his 'Reveries': *Earth and Reveries of Will*, *Earth and Reveries of Rest*, *Water and Dreams*, *Air and Dreams*, *The Psychoanalysis of Fire* and *The Flame of a Candle*. In that context we can also see a blue monochrome by Yves Klein not only as an absolute of colour, but also as a pure space, free of history – the perfect equivalent of air.

The body

In modern art the body is as present as it ever was but it is no longer subject to the old rules of proportion and posture which had established it as the image of Beauty. At the end of the nineteenth century art had already done away with those conventions by dispensing with professional models or going without any specific individual subject. Rodin, Manet and Degas wanted to show the body in all its truth, whereas Cezanne with his imaginary *Grande Baigneuses* saw a link with the earth of our origins. Morality continued to hold sway for some time – even as late as 1900 people still insisted that nudes should conform

to convention as much as real people did, but those attitudes were gradually laid to rest and it was eventually acknowledged that prudery was not a valid aesthetic criterion. With Manet's famous *Dejeuner sur l'herbe* of 1863 judgements about a work's quality and its level of 'decency' were finally disentangled. Since then, artistic representations of the human body have enjoyed ever-expanding freedom.

Anatomical accuracy and codified seduction techniques have given way to the body's need to evoke something no matter what that body might look like. Flesh is more expressive than a silhouette and skin conveys so much more than the mass it covers. Modigliani's large ochre nudes seem to express nothing more than voluptuousness and pleasure. But when they were exhibited in the middle of the First World War they caused a scandal because they seemed to disrespect those dying in the trenches. Their earth and brick-coloured tones evoke the very earth from which, according to Genesis, Adam was created (Adam in Hebrew translates as 'red earth'). That example just serves to illustrate that thenceforth general evocations could be more successful than single illustrations. Even so, at the end of the 1940s, the twisted vomiting bodies of Francis Bacon's art conveyed not so much a gratuitous desire for destruction as the desperate search for residual, hidden, or fleeting certainty hidden in the folds of humanity. And each of Lucian Freud's nudes assumes both the weight of experience which grinds us down and the innocence which lays us bare. Both are exposed for all to see – vulnerable and defenceless.

The body is a major subject in modern art but it also becomes one of its tools or supports. Yves Klein used live models covered with blue paint instead of brushes to paint with. Others used their own bodies as both subject and material in a kind of sacrificial mime (Michel Journiac, for instance) as though no external body could do the job.

Sexuality

Modern art has no need of the circumlocutions at play in traditional art. Artists like Egon Schiele and Oscar Kokoshka exposed the raw reality of sexuality from the earliest days of the twentieth century. The battlements of conformity were well and truly blown apart when Sigmund Freud and then Carl Gustav Jung revealed the power of humanity's sexual desires and the depths of the

subconscious. That is not to say that art was necessarily directly inspired by Freud and Jung at the time – even if that did happen later on, in the work of Salvador Dalí for example. There was no need for such inspiration as art had long ploughed its own furrow in the field of sexuality. Modern art simply rediscovered the explicit nature of certain ancient pieces like the erotic frescoes of Pompei (first century AD). After centuries of Christian morality, bourgeois conventions and prudery – at the end of the nineteenth century people had even gone as far as to cover up naked piano feet for fear of decadence – a whole aspect of human reality was set free, and the shock was enormous.

As a result people changed the way they looked at and interpreted traditional art. So a painting like *The Origin of the World* by Gustave Courbet in 1886 can't have seemed as revolutionary as it might be seen today. It was conceived for the personal enjoyment of the man who commissioned it – it was to serve a purpose and was never intended to be exhibited. The aesthetic and intellectual stakes were set low. Hanging it alongside other paintings from the era as though its frankness was designed as a statement on the prevailing hypocrisy is to quite misunderstand what it was designed to do.

Animals

Treated on various symbolic levels the animal is a major motif in modern art. In the past they were used as symbols of good (faithfulness) and evil (sensual pleasure). The dogs and cats of Bonnard were deployed in paintings to add harmony to a space – they would bring their petulance or their nonchalance without playing any moralizing role. Nevertheless it was most often the case that animals evoked mainly positive concepts in contrast with the human condition. So the horses, deer and tigers painted rainbow colours by Franz Marc around 1905 attempted to reconnect with the perfect light of Paradise lost.

When it comes to performance, animals have sometimes taken centre stage: a live coyote, a horse and a dead hare have all been interlocutors for Joseph Beuys in his public 'actions' *I like America and America likes me*, *Iphigenia*, and *How to explain pictures to a dead hare*. Many other artists, including Robert Rauschenberg, Tim Noble & Sue Webster and Maurizio Cattelan have used stuffed animals – no longer trophies or reserved for educational purposes but put to a more theatrical use.

Humour (as used by Jeff Koons) and the emotional dimension (Louise Bourgeois) are very significant factors in the animal theme – all the more so because they draw on a hybrid repertoire, from comic books to cartoons. In that sense the art of the second half of the twentieth century has as much to do with Alice's Adventures in Wonderland and Disney films as with the Renaissance cabinets of curiosities. It's simply replaced the unicorns of medieval legend with grinning cats and drunken elephants.

The sacred

Certain subjects and motifs – like the cross for instance – have never really disappeared from art, however, like other themes, they form part of a meditation on the human condition independent of any specific religion. When Matisse said 'Any art worthy of the name is religious,' he summed up the spirit of the nineteenth century, presided over by the notion of the hereafter – even if that notion was sometimes called into question.

In fact art is about searching for, waiting for, even defying the transcendent – with or without God. Which explains why certain works that set out to question how the world came to be rather than to celebrate divine creation, are very pared down. In that regard *White square on a white background* by Kazimir Malevitch, where you can just make out a square starting to be distinguishable from the background, is a modern kind of icon. The same can be said of Barnett Newman's huge canvasses crossed by a single black line which he calls a 'zip' – they simply aim to capture the moment and location of an inaugural decision that changes everything. The line divides the canvas and separates the materials from one another whilst at the same time creating a route into the possibilities of history and the processes of life. With that, a work can become almost liturgical. And that is when the connection with the sacred makes itself all the clearer – it's no longer anything to do with illustrating religious subject matter but about an intellectual attitude and a clear link to the rituals which gave rise to art in the first place.

Time

Since the Impressionist era the real world has often only been portrayed very vaguely – its outlines have blurred to convey a quick and partial perception. And yet – and this is one of the characteristics of the new style of painting that so scared its contemporaries – this style can more than hold its own next to centuries of artistic tradition. That is to say, not only does it no longer transmit any knowledge, per se, but it also takes pleasure in painting the inexpressible. Images no longer report a fleeting reality – they go along with it. The mobility of the visible and the accompanying loss of precision are now the stock-in-trade of artists and technological advances have now confirmed what Monet or Renoir observed from the door of a suburban train. The speed of the machine, heralded by Italian Futurists, the syncopated rhythm of the factory transposed by Fernand Léger, would henceforth find their counterpoint in the torpor of the scenes of American life captured by Edward Hopper or in the properly Olympian classicism of Brice Marden's or Soulages' huge constructions.

Twentieth-century artworks might be fragile, ephemeral, perishable and sometimes even capable of self-destruction – like Tingeuy's machines. They can no longer depict time because in some ways they simply don't have the time to do so.

The artist's toolbox

The twentieth century saw spectacular renewal in terms of artists' materials and techniques. As a result, the contrast with the output of the previous centuries is so stark viewers often feel modern art is completely cut off from what went before. But in fact, the aim for modern artists was to be as true as possible to reality. All our exposure to traditional art has done nothing to prepare us for modern art's simplicity of expression but viewers only needs a few simple keys to unlock its appreciation.

The freedom of technique

The criteria which had traditionally been used to evaluate artworks – the composition, the use of colour or materials for example – had already been seriously thrown into question by the Impressionist vision. Light sketches of vague shapes by Monet for instance aimed only to *suggest* a fleeting vision, a parallel world unencumbered by traditional definitions. And as images were freed from the tyranny of precise drawing and the conventional artist's palette they began an irreversible process of development – confirming what Charles Baudelaire had declared a few years earlier to Manet: 'You are but the first in the decrepitude of your art.'

From that point on it was the meaning of what an artist wanted to express that would determine the means they used. The only principle was that form should fit with content. And all sorts of forms have been used to convey hesitation, pain, pleasure, revolt and chaos through images which float, cause pain, soothe the eyes and hurtle the viewer into a haze of colour and brushstrokes. When Matisse was painting the Stations of the Cross in the chapel at Vence a few years before his death, he confessed, 'It's impossible to paint the passion without trembling . . . '. That trembling, which would earlier have been taken for an inability to draw, thus became an essential feature of the work, synonymous with the painting's meaning. The twentieth century saw the development of all sorts of processes aimed at underlining the same coherence of form and content – including collage, rips, marks, stains, lacerations, repairs and all sorts of other combinations. The paint itself was no longer necessarily applied using a brush. Max Ernst for example used all kinds of different materials to make marks with

and Jackson Pollock invented his famous 'dripping' technique. Sculpture also broke free of the strict rules of scale to benefit from moulding and assembling techniques whose possibilities are endless.

The liberation of colour

The first technical revolution of the twentieth century was the explosion in the use of colour as a tonality and also as a material in its own right. Colour became so intense and so dense as to be almost violent or 'screaming' as Van Gogh wrote about one of his portraits (*Le Zouave*, 1886). It took on a life of its own, separate from the objects it had previously only served to describe. For instance, green was no longer limited to being 'leaf green' it could simply be 'green' in its own right and could even be used as the single colour in a monochrome painting. Of course the expressive qualities of colour were clear from the early years of the century, as much in the work of the Fauves as that of the Expressionists, particularly in Germany. Nevertheless it is not colour alone that decides the full meaning of a piece; context will always be essential. On its own a red cannot definitively be understood to convey joy or passion (Matisse) or even the most terrible anguish (Chaim Soutine) because it can express any one of these equally well – the rules of historical painting, which still apply in the context of historical painting, remained at least partially valid in the twentieth century. So in the work of Joan Miró, Matisse or Yves Klein, blue, which had symbolized the Virgin and holy eternity since the Middle Ages, continues to represent the abstract, or inaccessible even without any literal reference.

Black and white

The use of black and white comes more from the tradition of drawing than painting and supposes a focus on the basics, on the sketches and drafts that traditionally constituted the basis of a work. Black and white appear in the realm of preparation and, of course, of writing. They emphasise the essence of what is 'said' – or rather the thought that inspires an image.

Once again Picasso played a key role. When he decided to paint *Guernica* in black and white he was aligning his means of expression with the newspapers which broke the story of Guernica's bombing. So the painting was both a picture and a text; snubbing any nuances which could have distracted from the central message

or diluted the brutality of the facts. Guernica presented a world divided in two between black and white. There were no half-measures or compromise, only dead areas in stone grey. And because of that the work was quite unique in its legibility. Commentators highlighted the links with Far Eastern calligraphy and it inspired numerous artists after the 1940s, particularly in the USA. Fascinated by Picasso's work, which was exhibited in New York, young painters discovered in it an alternative to realism, as well as a true commentary. The development of this new vocabulary is to be seen in the works of Franz Kline, Jackson Pollock, Willem De Kooning, Ad Reinhardt and Barnett Newman.

A new concept of space

Since the Renaissance it's been understood that the space of a painting is much like that of a stage in a theatre. The use of perspective creates the illusion of depth into which the viewer can project themselves, navigating with the usual terminology that applies in the real world – foreground, background, measurable gaps, high and low, and so on.

In the twentieth century there was nothing exclusive about that sense of perspective and the different concepts of space multiplied as much as the arts themselves. Without setting out to be scientific about it, artists saw the frames of their work as a sounding box, open to all sorts of influences. So the space of a painting became a continual stream of consciousness, a little like a piece of text with no punctuation. And the canvas became quite capable of representing a cosmic space – it could be anything from the infinite space of the universe (see work 12) to the tiling on a façade or even a town plan (Mondrian in *How to Talk to Children about Art*, work 24). Sometimes the canvas follows the logic of memory or fairytales and depicts a topsy-turvy world (Chagall in *How to Talk to Children about Art*, work 22). Elsewhere it brings sense to the trickles of paint amongst which the viewer may be struggling to find his way, because the canvas presents the world either as a huge labyrinth (Pollock in *How to Talk to Children about Art*, work 26) or as the layers of an archaeological dig to be analyzed. In the end painting gets submerged in its own material, sensitive to the least wrinkle or breeze (Klein, *How to Talk to Children about Art*, work 27). Sometimes it catches in passing snatches of shape or colour like a sound wave (see work 2).

In any case this approach to space also takes into account the approach to the canvas: its objective presence is even more emphasized now that traditional illusionism has been laid to rest. The work itself highlights the media, the brushstrokes or the colour and so makes the three-dimensional frame stand out all the more – to the point where sometimes the paint may colour the frame.

Simplification of images

Generally speaking, a modern or contemporary piece of art is visually far simpler than its traditional counterpart. It's no longer a matter of description – because the details shown are strictly linked to reality they are of very little consequence, so the shapes can be more directly eloquent. The process of stylization and the desire to jettison anything that is not vital to the image can sometimes be fairly extreme and we are left with some geometric shapes, a collection of lines or even a monochrome canvas.

Nevertheless, that certainly does not mean that modern paintings are devoid of meaning. When you look closely you may well realize that it is far more meaningful than you had at first thought and the deceptively simple style belies the absolute mastery of the painter. Elsewhere, modern art sidesteps literal representation, preferring allusion, association of ideas and poetic echoes. So even more than responding to the numerous references, understanding a work often demands that you simply give your imagination free reign.

The network of lines crossing each other at right angles in a Mondrian painting can simply be considered an austere exercise in geometry. But you could also recognize in it an absolute synthesis of images – streets viewed from above, an interior wall of a building mid-demolition, a plan of an apartment, the hugely blown up image of a web, a tightrope or a reservoir of light or breathable air . . . It speaks of all of that at once, without actually describing anything. That's why no matter how uncluttered or empty a work may appear it is in fact completely 'full'. To get a handle on what the artist may have had in mind and avoid getting lost, you may only need a dictionary entry, a few lines of biography or a history book.

Borrowings from other cultures

African art was 'discovered' in Europe around 1905 by André Derain, swiftly followed by Matisse and Picasso. People were very interested in the 'Negro' masks – as they used to be called – even though they were completely ignorant of the origins of that kind of art. Back then nothing was understood about their provenance, the significance of the shapes and colours nor even their usage. There were no texts to explain these objects which filled Western artists with a whole new sense of freedom – as they no longer had to grapple with centuries of obligatory written references related to the subject matter of the past.

Twentieth-century art is expert at seeking inspiration far afield in both time and space. It manipulates and mixes ideas borrowed from other cultures that have no links to the traditions of antiquity or Christian heritage. Far Eastern thought and writing (the Impressionists had already studied Japanese printmaking) or Native American rituals (Pollock) mingle quite naturally with echoes of Mesopotamia (De Kooning) or with Palaeolithic remains (Tàpies). In some respects the interest that modern artists hold for the painters and sculptors of pre-history comes down to the same thing. It is about awakening the spirit, getting out of a rut, laying aside preconceived ideas, washing away useless ornamentation and restoring art's vigour.

Using real objects

Industrial society, with its over-abundance of consumer goods and their correlated mountains of waste, provides rich material for artists. Since the early 1960s objects have been ever-present in art: manufactured and brand new in pop art, ramshackle and rusty in the work of Tinguely, stripped of all meaning or aesthetic interest for Marcel Duchamp or even at the other extreme, carrying as much profound symbolism as musical instruments (the piano for Joseph Beuys, Arman and Rebecca Horn). Like a precious relic the object itself becomes isolated, not in material terms, but because it appears to have survived some cataclysm, or at the very least to have resisted being forgotten. Objects can be amplified and collected in a series (Arman) or condensed like the cars in a wrecker's yard (César). Sometimes they combine with other materials and take on a new life of their own. Hijacked, rescued, saved, modified or in their original form, mundane or dreamlike, they offer a pragmatic alternative to traditional

artists' work, refreshing the imagination or reawakening memories (Christian Boltanski, work 25)

Fragments and repetition

Traditionally, pieces of art present themselves as a whole. Even when a painting, fresco or sculpture from the fifteenth or seventeenth century was designed as part of a cycle (a set of historical facts, the life of Christ or a saint, for example) each element stands alone as a complete image. On the other hand, many contemporary pieces, although designed expressly to stand alone, only fully make sense when viewed in light of what has preceded and followed them. This is all the more obvious when they deliberately take on a fragmentary appearance. Faced with pieces of art like that the viewer must act like an archaeologist – where the untrained eye might only see dust and debris, the archaeologist may see a shard of pottery and make the connection with a significant past event or even with a whole civilization. This segmented perspective is not only reserved for pieces designed to have the appearance of ancient artefacts, it is also prevalent in the most modern of works. It's a question of recalling the concept of totality – totality of the visible and totality of knowledge.

This approach can make some works appear a little repetitive. In 1891 Monet had in fact initiated the concept of the series paintings with his fifteen canvasses each showing one or two haystacks in different light. Following the same logic, painters in the twentieth century re-painted the same pictures with infinite variations (Pierre Soulages, Robert Ryman). Inspired by industrial modes of production they sometimes chose to systematize this multiplicity (Andy Warhol). Even if the pieces are not identical, in some cases their fixed theme became a recognizable signature of the artist (Daniel Buren, Claude Viallat) signifying in perpetuity the obstinate presence of art.

New Technologies

From the 1820s the very latest technology made its exhibition debut in the form of photography. In aesthetic terms photography was largely underestimated by painters and sculptors who saw it only as a useful aide memoire. But photography very quickly established its own domain without posing any threat to the art of those sculptors and painters. Today more than ever it maintains a relationship

with reality founded on fascination but also independence – creating a true second reality – often all the more troubling because people too often have the tendency to see it as purely objective.

Recently, new technologies have multiplied contemporary art's opportunities for expression and production, but in their own right these technologies also present new fields of reflection for artists. Beyond processes like video (Nam Jun Paik, Bruce Nauman and Bill Viola) or computer digitalization, artists and their technical teams (Jeff Koons, work 22 and Murakami, work 27) have mastered techniques that demand a new relationship with reality. The work is no longer simply a result of handling materials but also represents images of the virtual world. Though it has new means at its disposal – which it excels in combining – it still does not diverge from its path. It continues to explore, to question and to reinvent the world.

About the artists

We do not intend to provide a list of twentieth-century artists (it would be far too long) nor a list of those credited with starting the various artistic movements of modern art. We simply wish to note the importance of certain personalities so significant that they profoundly changed the way art was conceived in the twentieth century. We also want to make some more general comments about the role and the activity of the artist.

Pablo Picasso (1881–1973)

For many people modern art is all about Picasso. He is immediately associated with a certain type of image – the 'jumbled-up' face, all disjointed and unrecognizable. With the arrival of Cubism Picasso, along with Georges Braque, effectively renewed our vision of reality; presenting a jarring vision that echoes the riskiness of perception. It was no longer a question of pure description or outline but a collection of notations, never complete but which together aimed at conveying an experience. So a fruit bowl was no longer a simple object of specific size, but became a succession of memories and hypotheses carefully stored away: the sum of the looks it had received.

Picasso certainly followed in the footsteps of Cezanne who had pioneered the approach towards the end of the nineteenth century, but he transposed Cezanne's approach to space – what is visible of an object from one or more points of view – into the realm of the emotions. By deforming a body or a face he conveys a reality that is not normally visible, he paints the interior reality of someone who at that moment feels 'broken', 'muddled' or 'shattered'. His monumental composition, *Guernica*, painted in 1937 in response to the bombing of the small Basque town of the same name, is a clear demonstration of the approach.

So visually we have the right image of Picasso even if we sometimes draw the wrong conclusion from it. There is nothing flippant in the way he depicts reality, on the contrary he is being perfectly true to humanity.

Marcel Duchamp (1887–1968)

At the beginning of the twentieth century Marcel Duchamp asserted the power of his personal choice on the intellectual and material value of a work. An

everyday object could become a work of art simply by virtue of being displayed in a museum. Duchamp was inviting us to reflect on the extent to which the ideas of the artist, and the significance and authority of the institution play a determining role in influencing how viewers *see* art.

Duchamp exhibited all sorts of finds over the years, including a porcelain urinal entitled *Fountain*, a bottle holder bought in a department store and a bicycle wheel attached to a stool. His independence of spirit, mixed with intellect and humour, made Duchamp's work a significant watershed for younger generations – including the Surrealists. The demonstrations of the 1960s (the student protests in Paris and the anti-Vietnam war demonstrations in the US) were a significant challenge to traditional authority and the protesters took Duchamp to their hearts. More than fifty years after his death he remains a huge influence on many artists.

We mustn't forget that in Duchamp's view none of his 'ready-mades' actually constituted works of art per se. It would be ridiculous to consider them to be art when they were conceived precisely to establish an alternative to the way art was traditionally seen. A ready-made is a gesture, a discourse in three dimensions, a means of stopping the viewer in their tracks and having them examine their own way of seeing – as opposed to the object laid before them.

Andy Warhol (1928–87)

Andy Warhol was the founder and central figure of Pop Art and in many ways symbolizes the spirit of the 1960s and 1970s. The world of advertizing, where he started his career as an artist for magazines like *Glamour*, *Vogue* and *Harper's Bazaar*, now governs the way we relate to images and Warhol was the first to get the full measure of that development. From the outset his work was based on commercial photography; taking its simple shapes and limited palette of striking colours and turning them to his own ends. Rarity – which had previously decided the value of a piece – was trumped by the principle of reproduction and open access to the largest possible number of people. Immersion in an abundance of images – photos, posters, magazines, cinema and television – constituted a new and irreversible reality. It was no longer enough for art to isolate itself from the vulgar but on the contrary it had to immerse itself in the crowd. Visibility became confused with fame and started to hold a value in itself.

By setting up his New York studio in an old warehouse which he called the Factory, Warhol was sending a clear signal that he saw the work of the artist in terms of productivity, very much in keeping with the values of contemporary society.

At the same time his work also constitutes a lucid analysis of contemporary society's crutches – superficiality, impoverishment of the senses, the banality and uniformity of ideas, indifference, manufacture and the dissemination of images of those new gods; the stars of stage and screen.

He was not only a painter but also a writer and film director. Andy Warhol also developed his own personal image – steeped in the day-to-day but also exhibiting his extraordinary artistic sensitivity. His look – with a silver wig and dark glasses – was an integral part of his work.

Joseph Beuys (1921–86)

Born in Germany, Joseph Beuys was planning to become a doctor at the end of the Second World War, when he discovered art. In fact he became the epitome of a modern shaman – the individuals who, in primitive societies, communicate with the spirits, bringing peace to troubled souls and delivering people from their terror of the hereafter.

His different works let him recount snippets of his life as he had lived them (in reality or otherwise) – and in reporting them, he formed the mythical origins of his own work. Shot down when he was a Luftwaffe pilot he claimed he was rescued by nomadic Tartar tribesmen who wrapped him in a felt blanket and put grease on his wounds. That is why his work is loaded with those very same materials: felt, grease, copper wire and plaques are all chosen for their ability to warm and to transmit energy. To them he adds other objects like blackboards, pianos and sledges, which to different degrees evoke the importance of thought, and the power, sometimes salutary power, of the word. Coining the phrase 'Social Sculpture' he declared that art is first and foremost an intellectual activity – an option for any man called by his need to 'sculpt' the outlines of his presence in society and by so doing to become the master of his own mind.

Beuys's personal charisma was very important, conferring upon him enormous influence and almost prophetic stature – his personal trauma allowed and justified his symbolic stewardship of German history during the war. It matters

little whether the episode of his being shot down and saved happened or not. It is absolutely true because its retelling is better than any factual chronicle – it conveys the reality of the experience, the terror of death, the horror of killing and the simple humanity of salvation – even salvation from the oblivion. What he called his 'actions' refers to both his discourse and his staging of works in which he, the artist himself, was always a central figure. They would last several hours or even days in galleries or museums and encourage consideration of both guilt and redemption.

His works often seem difficult to understand – not because they are complex but because they are presented in such a jarringly stripped-back manner, like signs on the road to reconstruction for a whole civilization. A sceptical viewer standing before a pile of grease or a piano wrapped in felt must recall that these pieces are nothing but the pale memory of a dazzling, unique personality. If they appear to be missing something it's certainly not authenticity or intelligence or even beauty. It's simply the presence of that presence.

Painters, sculptors and artists

These days it's more common to use the term 'artist' than 'painter' or 'sculptor' which suggest a particular specialism. An artist's work is no longer as clearly defined by their technical knowledge as it once was. The apprenticeship routes – art school, winning prizes and then public commissions – are much less systematic these days and there is no longer a predefined career path as there was in the nineteenth century. These days, as artists develop as individuals, they may be drawn to disciplines unconnected to their initial training. Nothing in Christo's original training as a painter, for example, prepared him for wrapping public buildings in gigantic awnings. Similarly, as Murakami was studying traditional Japanese painting, he was unlikely to have dreamt of his current repertoire being so close to cartoon art.

On the other hand, it's sometimes difficult for the viewer to imagine that a minimalist piece – a monochrome or an installation – could have been produced by an artist who had really been classically 'trained' at all. But that is to mistake the refusal of classical techniques with ignorance of them. And we should add that if a piece seems gratuitous because it disorientates the viewer this too is the result of the artist's own logic.

What is more, these days artists very often train themselves – with collaborations, reflection, admiration and technical inventions. That they may take non-traditional routes doesn't in any way devalue their work, for which the only valid criteria is expressive authenticity.

Female artists

There were female artists in antiquity, just as there were female artists in the Middle Ages. But it wasn't until the Renaissance and in particular the sixteenth century that some were able to forge true careers, thanks to the development of humanist thought which allowed for females to be educated.

In the centuries that followed women were increasingly welcomed (though still somewhat warily) into academies and exhibitions – but they remained very much in a minority, both in number and in the significance of their work. In the twentieth century the distinction is no longer so valid. Just as the old restrictive ideas of a woman's role in society were overturned, so there was an explosion in the number of female artists. Even if militant feminism was not necessarily the subject matter of their work, nevertheless, from the 1960s onwards, these artists brought fresh, new themes and points of view, informed by their (sometimes tragic) experience of 'feminine-ness'. One can cite Sonia Delaunay, Georgia O'Keeffe, Niki de Saint-Phalle, Joan Mitchell, Aurélie Nemours, Germaine Richier, Barbara Hepworth, Louise Bourgeois (work 28), Agnès Martin, Eva Hesse, Nan Goldin, Cindy Sherman, Annette Messager, Jana Sterbak (work 23), Sam Taylor-Wood, Tracy Emin . . .

Partnerships

Christo & Jeanne-Claude and Tim Noble & Sue Webster worked, or work, in partnership. The division of labour, if it is covered at all during the preliminary stages of a project's conception subsequently becomes part of the work itself – to the point where it is not possible to distinguish the input of the individual artists. This is quite a frequent phenomenon in the second half of the twentieth century, facilitated and to a certain extent caused by the techniques used – from photography to different kinds of installation. It's noticeable that these works with two voices are often quite divorced from abstract expression. In addition to those mentioned above, we should mention Jake & Dinos Chapman,

Pierre & Gilles, Eva & Adèle or even Jane & Louise Wilson. Amongst the precursors of the technique stand Gilbert & George. Together since the 1960s, they have played a crucial role, as much in their production of images (a combination of photography and painting in a very Pop Art spirit) as in their performances.

Art as autobiography

The self-portrait has been with us since antiquity and popular since the Renaissance. Up until the twentieth century one could find self-portraits both as independent works and as small elements in larger scenes. What's new is that nowadays artists tend to consider the whole of their oeuvre as a legitimate space for autobiographical reflection. They use their art to project their memories, fantasies and hopes (works 14, 25 and 28) and in so doing place their art somewhere between chronicle (Sophie Calle) and self-aggrandisement – including many, and occasionally contradictory guises, in between (Cindy Sherman).

The artist's private life also acts as a prism through which he or she can observe or make sense of the outside world. In some cases it was no longer merely a question of individual experience as subject matter, but also of material: the artist's body itself being incorporated into creative expression and the production of meaningful artefacts. For example, at the end of the 1950s Piero Manzoni exhibited inflated balloons entitled *Artist's breath* followed a year later by tins entitled *Artist's shit*. To suggest the artist's body was so sacred as to be worthy of displaying its excrement was obviously provocative but it also clearly evokes the Christian tradition of relics (the blood of Christ, milk of the Virgin, bones of the Saints and so on) ironically underlining the link with the history of art.

To a certain extent then it is possible to understand artists' 'performances' or 'actions' as demonstrations of which the artist's being – their body, mind, appearance, movements, words and even their breath – is the only real subject possible and it recalls the very idea of creation: that of man 'in the image' of and resembling God.

Artist's words

One of the most frequently asked questions about art is actually about the artist's words: 'Did the artist provide any explanation of what this means?' Though it's tempting to respond that art is a language unto itself with no need of translation or further commentary by the artist, nevertheless in the twentieth century there is much more available in the way of explanation than there was in the past.

Modern artists, very aware that their work was breaking with tradition, wrote a lot more about it than their predecessors. Many of them were teachers – which also goes some way to explaining this trend. So it's possible to read the words of Matisse who taught for a while in Paris or of Kandinsky who was a teacher at the Bauhaus from 1922. (The Bauhaus was a school of design founded during Germany's Weimar Republic in 1919, and whose influence was felt through the whole of the rest of the century.) Elsewhere over the last few decades the media has offered artists the opportunity to discuss their work – access to interviews, written or filmed, is hugely valuable. The simplicity and sensitivity of their words is often surprising, inspiring and very touching. Unfortunately we can't hear the voices of Raphaël or Rembrandt but that shouldn't mean we ignore those of Robert Rauschenberg, Pierre Soulages or Christian Boltanski.

Art in museums and elsewhere

Modern and contemporary art museums

The last few decades have seen an explosion in the number of museums dedicated to modern and contemporary art. Some have been established in old buildings renovated for the purpose, others are housed in purpose-built spaces. In either case the demands of current museography prevail – sensible visitor routes, lighting, security and so on, all designed to help visitors have a more or less informative dip into the art on show. The key is that the place itself has become like a work of art. These days the perfect museum is an empty space dedicated to the contemplation of the art it houses. So sometimes when newcomers first visit one of these remarkable edifices that seem to promise a series of further spectacular discoveries they can be a little disappointed. But once over the threshold they understand that they haven't so much entered a building as a concept, punctuated by the works on display.

The renovation of old buildings works on the same principle: the Hamburger Station in Berlin, the Queen Sofia Museum in Madrid, the Tate Modern in London or Dogana in Venice have brought back to life vast spaces previously used as a station, a hospital, a factory and a warehouse. So these museums have become a part of a long history of places, forms and spaces that lend art a very particular resonance.

Single artist museums

Monographic museums used to be housed in the artists' workshops or homes – like the Eugène Delacroix, Auguste Rodin, Frida Kahlo and Gustave Moreau museums for example. These days they are increasingly to be found in independent buildings. Whatever the architecture, single artist museums have the advantage of being able to display the whole of an artist's work often including rich archives of sketches and drawings as well as permanent, temporary and thematic exhibits. In fact Picasso is probably exceptional in that he has three dedicated museums to his name in towns where he lived: Malaga, Barcelona and Paris. Likewise there is the new Magritte Museum in Brussels and the Miró and Tàpies Foundations in Barcelona.

Traditional and contemporary

In parallel with chronological displays, exhibiting contemporary art alongside more historical pieces can be hugely illuminating. Many museums – the Louvre, the Musée d'Orsay or the Chateau of Versailles – bring together or even deliberately clash periods, so as to create a kind of dialogue or mirror effect that can be very thought provoking. It's a great way of discovering how modern artists saw and responded to their heritage either by unpicking it or by paying homage.

Art in nature

Almost by definition, Land Art is located in the countryside away from the crowds, and even if it weren't temporary by nature it would be difficult for the majority of fans to visit. In the case of Land Art the artist acts as a kind of high priest, changing the course of nature for a time with their use of earth, stone and water. But often all that remains of the work are the photographs. On the other hand monumental sculpture is also displayed outside – in town squares (work 28) and even in the heart of business districts but also, happily, in huge dedicated parks. Free from the typical constraints associated with being displayed in museums – like the route the viewer will take to the work, or even the lighting – sculpture displayed under the sky can come into its own. Bronze, stone and sometimes wood reconnect with their origins in sculpture parks – which are both a foundation and a source of regional contemporary art. In the natural context, the materials appear as pure, natural elements almost as though they had sprung ready-formed from nature without any human intervention.

What to focus on depending on their age

You can be completely open when you introduce children to art. Ideas of eras, subjects, styles and techniques mean little compared to the appeal that particular pieces will have to youngsters. That said, it is possible to measure or steer your approach based on their age so as to create the most favourable conditions for happy discoveries. With any age group the important thing with a visit to a museum is to avoid having a pre-determined programme or route – keep your eyes and your mind open.

AGE 5–7: WHAT THEY LIKE DOING
colour coded red

Understanding with their bodies
Little ones tend to want to 'look with their hands' and even with their whole bodies. Though they may not be able to touch they can easily *mime* a work. Above all for them it's a question of getting their physical bearings. As well as the media and the composition, any characters in a work invite children to – in their imagination – jump in, wander about, splash or have a paddle in the work . . . so that they are literally 'living' the story.

Imagining the artist's movements
The way an artist works their paint or other materials, leaves marks, juxtapositions and textures offers a way in for children – youngsters are particularly sensitive to the idea that the artist *was here*. They like to imagine how the artist might have gone about achieving a certain effect. So a good way for them to get to grips with the reality of a picture is by imitating the artist's movements or movements from their own daily lives (touching or sweeping across a surface, making piles and so on).

Making the connection between a work and reality
Many contemporary works use everyday objects either in their entirety or in fragments – little pieces of rubbish, machine parts, pieces of fabric . . . Children relate very well to these and may also occasionally see things that resemble their own 'treasures' and may well understand the artist wanting to work with such objects.

Making up stories

Paintings are full of wordless stories. Younger children will naturally follow all the movement – the shapes and colours, crossing and parallel lines, flying, sliding and falling objects – and they will enjoy making up adventure stories to go with them. To get them started you could look to the classic *Little Blue and Little Yellow*, a wonderful illustrated book by Leo Lionni.

Dig out the details

Little ones are often more sensitive to the details than to the whole and that can provide a great way in to works of modern art. But the approach is just as effective with art from any era. A small change in the drawing, or a tremble in the material can act a starting point for children but might go unnoticed by an adult who's too busy worrying about meaning and aesthetic judgements (work 18 for example). It can work just as well with abstract pieces as with figurative ones – a leaky tap in an artist's workshop can tell as much about the artist's mind as any set of theories (work 19).

Discovering museums

It may well be easier to introduce children to traditional art with books and pictures but it's preferable to take them to modern and contemporary art museums as early as possible. These are usually huge, light spaces where they can wander fairly freely and discover the real format of pieces as well as their significant connections to the space. A photo of a Soulages polyptich may not capture their attention, but seen for real, in all its imposing size, it is bound to make an impression.

Categorize as you wish

Modern art is full of contrasts and extremes and children will quickly establish their own categories. They may not be based on artistic criteria but they will go hand in hand with their own discoveries and help them to remember them. In a single room at a gallery try having a game to find the largest and the smallest paintings, the most or the least colourful, a square canvas, pictures with different shapes in them and so on. It's a great way for adult and child alike to take the time to look at what might not have otherwise caught their attention.

AGE 8–10: WHAT THEY KNOW HOW TO DO
colour coded yellow

'Getting' an idea

Beneath the surface of the painting children are often able to discern the artist's feelings. They quickly notice any hesitancy in an outline, the brushstrokes or colours or less precise areas of a sculpture. At that point, it's good to help them realize that all these elements they have noticed are the result of deliberate choices taken by the artist, perhaps to convey hesitation or a feeling of difficulty.

Engaging all their senses

For conservation and security reasons we're not allowed to handle works on display in museums but it's worth remembering that they often appeal to our sense of touch and the effects of texture can be very evocative. The same can be said of the other senses – in particular hearing (work 2). Children naturally grasp the connections artists suggest.

Finding recurring shapes or figures in the same artist's work

Recurrent shapes or figures are to be found in certain artist's work. They become like elements of their vocabulary (geometry for Mondrian, for instance) or familiar faces (Bonnard's wife Marthe often hardly visible in the colour wash of a painting). They may be close to reality or completely imaginary but they are always significant in the general context of a work. Children quickly get familiar with figures like this – the bird Loplop in Max Ernst's paintings, for example, or Mr Dob in Murakami's.

Finding the same shape in different artists' work

This is the same game as outlined above but the emphasis is on noticing the *differences* this time: a rectangle adds balance to a Mondrian painting but flies off into infinity in a Kandinsky. You can play the same game with all sorts of basic shapes – crosses, circles, diamonds, checks and so on.

Take an interest in animals

Animals often appear in modern art and usually carry some kind of symbolic meaning that children will find interesting. The expanse of a Braque canvas

crossed by a huge bird, the wild and yet mechanical power of Raymond Duchamp-Villon's horse and even the presence of a real coyote in a performance by Joseph Beuys are all chances to awaken children's sensitivities to art.

AGE 11–13 AND BEYOND: WHAT THEY COULD DO
colour coded blue

Make the connection between works and their titles

Titles can be purely descriptive or they may be more enigmatic, creating a gap between what you see in the work and what it's called. The brevity or length of the title always speaks volumes about what the artist wants to say. The further divorced it is from the image itself, the harder the viewer has to work to understand. The fact that the artist must have selected the title themselves must be taken into consideration and is the beginning of any analysis.

Comparing different approaches to the same theme

A dream described in mechanical detail by Dalí is not the same as a dream evoked by the moving shapes in an Yves Tanguy or the metamorphozing individuals in a Miró. It's important to point out to children that the same word, the same theme or subject can cover a wide array of realities. When we say that such and such an artist or movement is interested in representation of dreams or of nature we are not actually saying very much at all. Just a little more specificity will help prevent children from falling into the trap of empty generalities.

Link works with the broad sweep of history

Artists work within history: it is both the milieu where they exist and the very substance of what they do. A Dadaist collage might appear amusing until you realize that it was created in the middle of wartime – the picture 'explodes' into pieces like a shell and all that is left of reality is crumbs. As the world cleared away the rubble of another war, Nicholas de Staël's paintings erected shapes like beams and scaffolding. They give a structure back to the world and offer it a chance to stand on its own two feet again. Though it may not be useful to have children cram their heads with lots of dates, it is possible to show them the very close connection between life as it is lived and artistic expression.

THE ARTWORKS

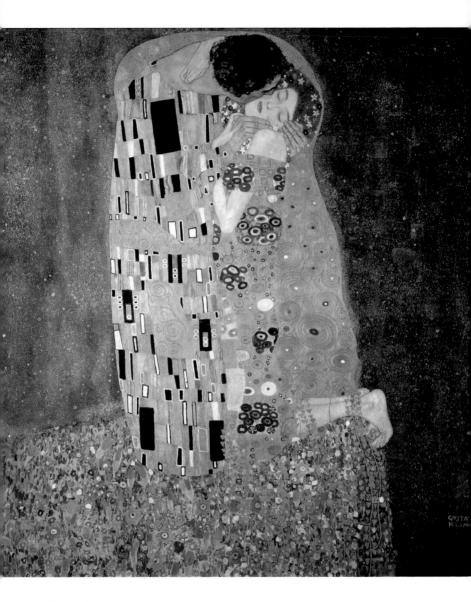

1 *The Kiss*

Gustav Klimt (1862–1918)
1907–1908
Oil, gold and silver on canvas
180 x 180 cm
Galerie Belvedere, Vienna, Austria

It's golden

This painting is decorated with real gold leaf so looks as precious as a jewel. It describes not just the world as we know it, but a wonderful, magical world. A world as beautiful as a treasure.

There are people

You can make out a man leaning towards a kneeling woman. But all you can see is the tops of their bodies, their hands and the woman's feet. This couple is both visible and hidden – the gold protects them.

They are in love

The man is kissing the woman, who is huddled close against him. She is letting herself be kissed. Nothing can separate them. The artist hasn't left any space between them, they are melded together.

You can see lots of flowers

There are flowers everywhere like in a garden; there are even yellow, blue and pink ones in the young woman's hair. The patterns on her dress also look like round bouquets and there are long golden stems climbing up from the bottom of the painting. It must be spring.

◊◊◊

They're wearing beautiful clothes

The man is wearing a kind of long coat, and the woman is wearing a fitted sheath dress. In fact their clothes look more like theatrical costumes and the artist gives each of them a particular style – for the man its straight lines in black and grey; for the woman circular, multi-coloured patterns. He separates rigidity and fluidity and then brings them together again with the gold.

You can't really see the people very clearly

The important thing is that they are a couple – the figures are only partially shown but the parts you can see (the hands and shoulders, the woman's face and her hair and feet) are painted with such precision that the people seem complete beneath their golden clothes. With a little effort you can start to see them as individuals. The same happens when you meet two people who are always together in reality – it takes a while to get to know them as individuals.

It looks like they are on the edge of a cliff

There isn't any scenery but the ground does appear to fall away and the drop has a dramatic effect by conjuring the idea of a fall into an abyss. It evokes the medieval paintings of monks at prayer on cliff-edges, suggesting the dangers of 'falling' into temptation. The young woman's feet are tensed; on the edge of the unknown, she senses that she might fall. Maybe she isn't sure whether she wants the kiss. Or on the contrary perhaps it is the kiss that will reassure and save her. The 'cliff' is simply a means of showing her apprehension.

Why is the man wearing leaves on his head?

The flowers evoke new life, and the vine with which they have been woven symbolizes immortality (like the laurel which retains its green leaves in winter) as well as poetry and faithfulness. This scene shows a dreamlike ideal of love, but the plant, as it grows, climbs and knots itself can also become smothering, and the space of the painting is opaque, as though starved of air . . . love can also become a prison.

Did Klimt use models?

Well, this is actually a self-portrait with the artist pictured wearing a crown (like a Roman poet), together with his partner Emilie Flöge. But Klimt wanted the painting to have a broader significance – as the two names he gave it suggest. At first it was called *The Couple* and later *The Kiss*. But above all it's about celebrating the role of the artist. He is holding the woman he loves in his arms. With his hands on her face – it is as if he is moulding her, creating her as a potter does with his clay. He makes his love a work of art.

◊◊◊

Isn't gold usually reserved for the background?

In medieval paintings gold symbolized eternity. It was also used in the mosaics that Klimt very much admired at Ravenna in Italy. Like many artists in the 1900s he wanted his art to mix – or at least to evoke – different techniques, to combine the different decorative arts (mosaic, tapestry, ceramics, enamels) with architecture, sculpture and painting. That harmony was the ideal of the Art Nouveau movement of which Vienna, where Kilmt worked, was one of the centres. In this painting the couple are surrounded by a golden cocoon, protecting them from the rest of the world and suggesting that their love makes them special – the elect.

Does gold have a religious meaning?

Just as it traditionally does, gold here suggests a different, better world. The artist chose the most precious of materials to depict the highest of spiritual values. But even though he's employing the symbolism of religious painting, Klimt applies it here to personal emotions and in so doing celebrates what is sacred for him.

Was it fashionable to depict kisses?

Yes, you see kisses in mythological subjects like Venus and Cupid, Venus and Mars, Cupid and Psyche and in literary works like Paolo and Francesca, two of the characters from Dante's (1265–1321) *Divine Comedy*. Kisses are also to be found in certain biblical stories. In the middle ages the kiss between Anne and Joachim symbolized the immaculate conception. What we see here is of course a stylized image of physical love but also of fruitfulness. Gold is a symbol of love which is itself traditionally associated with the life-giving word of God. But the picture of the couple fused together, encased in a shape reminiscent of a seed (or a womb) suggests something else – in the way a chrysalis pre-figures the butterfly. The splendour of this painting is but a promise of the beauty of the life to come.

The woman is kneeling – is she submitting to the man?

In historical paintings differences in height often symbolized hierarchy. But the pursed lips and the position of the woman's hands suggest that she is not unwilling. By kneeling she obliges the man to lean over her – meaning that perhaps he is the more submissive of the two. So the theme of the femme fatale, seductive and dangerous, is very much present here. Though it is highly decorative, this painting also poses questions about the power in relationships between men and women.

Is it true Klimt did the same painting but with naked people?

Yes, he did as part of the *Beethoven Frieze* several years earlier – and it caused quite a scandal. When he exhibited this new version of *The Kiss* it was much more readily received and in fact the ministry of Beaux Arts even bought it. People have often suggested that by dressing his figures Klimt was giving in to public opinion, but in actual fact the addition of clothes really just served to highlight the rigidity of society's rules. The gold represents a luxurious façade or the morality of bourgeois Viennese society which hypocritically stifled the reality of sexual urges. All of these were themes explored at the time by Sigmund Freud, the inventor of psychoanalysis and Klimt's contemporary.

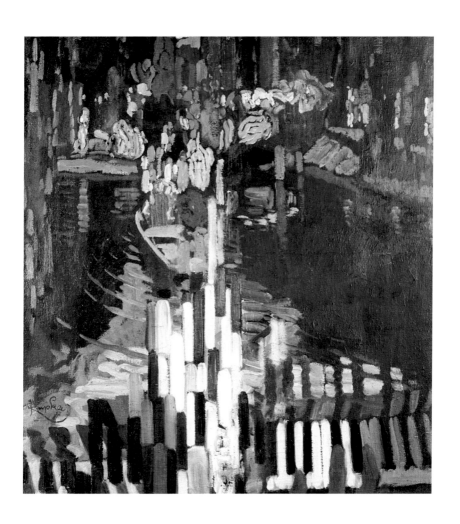

2 *Piano keyboard*

Frantisek Kupka (1871–1957)
1909
Oil on canvas
97 x 72 cm
Galerie Nàrodni, Prague, Czech Republic

You can see the piano keys

Yes, a keyboard fills the bottom part of the painting and you can clearly see the keys and the pianist's hand on the right hand side. But it's not the piano itself that interests the artist so he hasn't shown the whole instrument. He is more interested in the music.

It's by the edge of some water

We don't know exactly where the piano is – it might even be in the water itself! It certainly looks as though it's floating or gliding on the surface of the lake. You can also see brightly dressed people gathered on the far bank.

There are people going for a boat ride

It's a peaceful moment. The boat slowly and silently makes its way along and you can almost imagine the gentle lapping as the oars dip into the water. Everyone in the picture can listen to the music.

Some of them are in red

The red contrasts with the rest of the painting and the warm colour makes the scene seem more welcoming. It evokes the colour of flames. If you were to imagine the same painting without the red touches it would be much chillier.

It looks dark

The dark blue water makes it seem like evening time. But no doubt the trees around the lake are also blocking out the light. There is a reflection of a white cloud in the lake and in the distance you can see a little chink of blue sky above the mountains. Maybe it isn't so late after all . . .

◊◊◊

The boat is going round and round in the water

That little detail shows that the boat is in fact moving and as it gets further away the circles in the water get larger and larger. The drifting movement also suggests the sound of the music drifting across the water. The idea of movement is very important here because it also conveys the way music can carry the listener in its wake. It's a real voyage.

So is it day or night?

We can't say for sure – the music has made time stand still. Or then again it might be both day *and* night at the same time – with the piece of music wrapped up in time. Or there is also a third possibility; the dominant midnight blue colour evokes the term 'nocturne' which is used to describe a certain kind of music that has a slow rhythm and a lively middle-section – just like this painting.

The colours at the top are very different from the ones at the bottom

The bottom half of the painting is dominated by the alternating black and white of the keys which reminds us of the musician working on his notes and also of the painter working on his drawings. Both have to study and practice their scales. The upper part of the painting is a wild mixture of colours. From bottom to top the painting moves from conveying rigour and discipline to emotion and beauty.

What are the vertical shapes in the middle of the painting meant to be?

The middle keys on the keyboard seem to have detached themselves and become simple stripes of colour – Kupka is linking the piano keys with the brushstrokes. He's making a link between the pianist's movement and the movement with which he himself applies his paint. A brushstroke on the canvas strikes a chord on the piano and produces a sound. Together they form a bridge, a link to the outside world. The key thing is what they allow to be transmitted.

Why not show the whole piano?

Then he would have had to have included the pianist and it would have become a very ordinary generic scene. Kupka preferred to develop the landscape and to retain just a fragmented suggestion of the piano – as an instrument it fades into the background when compared to the power of the music. Nature itself is both the sound box and the composer's inspiration. And the shiny surface of the lake even resembles the varnished wood of a piano.

◊◊◊

You can't paint sounds!

That's true. Sight and hearing are very different senses – but since the end of the nineteenth century painters have often tried to go beyond those sensory limits. They have tried to suggest something equivalent to sounds. After all we

speak of a 'note' or a 'tone' of colour – as well as a 'touch' of paint. The water motif allows the painter to show the fluidity of movement between music and painting, between what is seen and what is heard. They are no more separate than reality and imagination. In 1908 Kupka had called one of his paintings *Yellow Scale*, focusing on the different shades of yellow a degree at a time as if he were focusing on the emphasis or the softening of a note.

Did Kupka play the piano?

No he didn't play at all. The hand you see here evokes the work of the painter which he likens to his own, for painting cannot stay isolated from the other arts. Kupka never learnt to play but even though he was far from wealthy he bought himself a piano as soon as he could afford to do so. Friends would come and make music in his studio. Apparently it was in listening to one of them who particularly liked to play Bach fugues that Kupka gradually evolved his work into something different – art founded on the interplay of colours and shapes.

Is music important in painting?

Music has been important in painting since the second half of the nineteenth century. Certain artists, like Henri Fantin-Latour, painted their memories of operas they had enjoyed (Wagner's music was a revelation at the time). And van Gogh, for example believed that the future of modern painting would be much more linked to music than to novels because painting's ability to suggest emotions was far superior to that of the written word. But it was particularly artists like Kandinsky, Klee and Kupka around 1910 who transformed paintings into colourful spaces full of tension and movement and capable – like a piece of music – of existing in their own right without imitating the real world.

Is it a figurative painting or an abstract one?

It's neither and both. It's a turning point in Kupka's work and in painting in general. You can see recognizable shapes but they are melting, drowning little by little in the lake. They become simply abstract stokes of colour. The work is like a metaphor for detachment; it says that pictures can throw off convention, leave visible things behind and enter an infinite space. Kupka was one of the pioneers of abstract art and had thought hard about the freedom which his predecessors instinctively felt (like Monet in painting *Water Lilies*). He wanted to explain what he was doing so he wrote a book in 1923, the title translates from his native Czech to 'Creativity in the Visual Arts'.

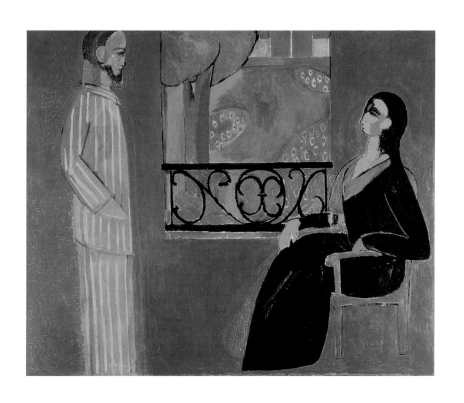

3 *The Conversation*

Henri Matisse (1869–1954)
1909–12
Oil on canvas
177 x 217 cm
Hermitage Museum, Saint Petersburg, Russia

The man is wearing his pyjamas

It's broad daylight, so it must be the morning and they can't have been up for long. The woman is wearing a dressing gown and has her hair down – which at the time when Matisse was painting was not considered a real hairstyle. They aren't ready to go out and clearly aren't expecting visitors.

It's nice weather

There's so much blue that it gives the impression of being a bright summer's day. But in fact the main part of the picture shows an indoor scene. The only piece of the outside we can see is a lawn and some flowers. The painter didn't want this painting to give a feeling of being enclosed, so he showed the walls in the colour of space – blue. The lady's collar is also the same colour as the grass.

There's no glass in the window

In real life there would have been glass in the window but a window frame dividing the panes would have taken up too much space in the painting and divided the view. The way Matisse has painted it, the window itself looks like a painting: he did that deliberately so that you can see two pictures in one.

What's it about?

There isn't anything specific going on. It could be the beginning of a story as the day is only just beginning. It's more about painting an atmosphere. We just have to allow ourselves to be caught up in the feeling of that calm place where two people are very focused on one another.

◊◊◊

Who are they?

It's Matisse and his wife. The faces aren't very detailed but you can tell it's a self-portrait from the little beard. And Mrs Matisse had brown hair.

Matisse has got his hands in his pockets

He's expressing himself without large gestures and probably also without raising his voice. He is concentrating and thinking as he speaks. It's not an argument, nor is he trying to persuade the lady of anything. But on the other hand he probably isn't saying *everything* that he's thinking. Some of his thoughts remain hidden – like his hands. Our bodies have their own silent language.

What can you see outside?
Beyond the tree and the red flowers in the flowerbeds you can make out a pink wall with a window in it. That's the studio where Matisse would go to paint every day. He only had to cross his garden to get there. The pink wall towards the top of the painting is at exactly the same height as his head, so we can deduce that the painter is actually thinking about his work. And that's probably what they are talking about too.

The armchair is see-through
It looks like it's made of Plexiglas but it isn't really transparent. The artist only drew the outline so that the picture remained nice and light. It's enough that we understand what it is without being distracted by the detail of the furniture. Painting the chair in that way allows the main colour – blue – to flow through the whole of the painting and fill whatever it wants to, including the chair. Matisse used the same idea in several of his paintings.

Are they wearing masks?
No. These are their real faces but they are conveyed using only their main features so they do look a bit like African masks (which had only been seen by European artists for the first time a few years previously). Like other artists Matisse was often inspired by these masks – they encouraged him to construct his figures with geometric lines rather than trying to imitate reality photographically. The expressions are so impenetrable that they transform the whole piece – making an everyday moment very solemn.

They are both in profile
By showing both the figures in profile Matisse isolates them from the viewer and puts them beyond everyday life. They don't catch our eye or pose before us but rather remain unaware of being observed, fixed in their own world. This is exactly the same technique as was used in the Middle Ages to show the dignity of kings and princes and, of course, in the ancient world emperors' faces were also shown in profile on coins and medals.

◊◊◊

His pyjamas look like prison clothes
Matisse's pyjamas are stripy, like lots of men's pyjamas, but it wasn't by chance that he chose this outfit for a self-portrait. As an artist Matisse is to some extent the prisoner of his painting. His work is his absolute priority and it is also 'hard

labour'. His horizons are limited both literally and figuratively by the wall of his studio and even the window itself could be mistaken for another painting as though there were no way out. Then again, the stripy pattern was typical of revolutionaries' clothing at the end of the eighteenth century – and for Matisse the act of painting was a true act of revolt against the conventions of the day. With these very simple means Matisse suggests that though he appears reserved, he is in fact an implacable rebel.

The railings are the most detailed thing in the painting

The loops and curls of cast iron create a visual link between the two figures. They are written in the air like a kind of script to be read from the man on the left to the right where they echo the woman's curves. Matisse often used curved lines to create harmony. Here the curve softens the tension of the scene. It's a breath between the words that are being spoken – allowing the voices to be heard without the figures having to open their mouths.

Windows are one of Matisse's favourite themes

He painted windows throughout his career – windows draw our eyes to the distance whilst keeping us aware of what is nearby. So with the window he would link what we can touch with what we can only see. Matisse isn't aiming to give an impression of depth so gives them equal importance here. Nevertheless he does still depict nature faithfully – the tree trunk is smaller so we assume it is further away. It's the perfect motif for bringing together contrasts; meditation (private space) and discovery (the view of elsewhere). Braque, Bonnard, Delaunay, Gris, Picasso and Magritte also explored the window theme very thoroughly.

What does *The Conversation* mean?

This piece treats a simple everyday scene with surprising intensity. The title indicates the importance of the relationship between two people. Matisse is referring to the traditional 'conversation' paintings which are based on the annunciation (the archangel Gabriel announcing the birth of Jesus to the Virgin Mary). He arranges the scene with himself in the place of the angel and his wife taking the role of Mary. In the centre there is an opening, not to the infinite, but on to his garden and his studio. He isn't aiming to paint a religious painting of course, but has composed it in such a way that he is figuratively symbolizing the conception of any work, with its roots in the everyday but also containing an idea of perfection. This painting is all about the task of the artist: formulating his thoughts, conveying a message and above all making the invisible a reality.

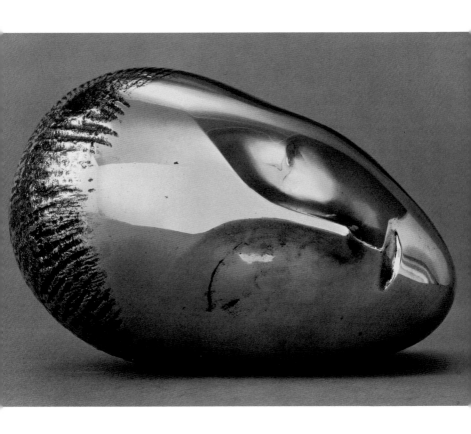

4 *The Sleeping Muse*

Constantin Brancusi (1876–1957)
1910
Polished bronze
16 x 25 x 18 cm
Pompidou Centre, National Museum of Modern Art, Paris, France

It looks like an egg

The artist has kept the muse's head as close as possible in shape to an egg as a means of suggesting the interior world. As well as the head, the sculptor wanted to represent the thoughts it contains. A thought can hatch and grow just as a chick comes from an egg.

She's asleep

Yes, or at least resting. She may even be dreaming. People move all around her but they don't disturb her. When you come close you almost feel like you should walk on tiptoe.

The sculptor has forgotten the ears!

That's what you think at first but sculptures are always full of surprises. If you stand behind the muse you see one of her ears half hidden by her hair. You might start off thinking she can't hear but then it turns out that she can, even without appearing to do so.

She hasn't got a neck

You can't see the neck either when you look at her face-on. But that's just as well because otherwise it would look like a severed head which is terribly violent and not at all in keeping with the idea of a muse. Not only that, but a neck would spoil the oval shape of her face – that's also a reason why the hair is pulled off the face into a bun at the base of the neck. From behind you can see that she is made just like anyone else.

◊◊◊

What is a muse?

In mythology the nine muses are the daughters of Zeus (Jupiter) and Mnemosyne (Memory) and companions of the god Apollo. They would sing together as a choir by his side to transmit divine inspiration to man (in fact the word 'music' derives from 'muse'). Each of the muses is associated with an art or a field of knowledge (poetry, history, astronomy and so on) and usually carries at least one symbol (a book, a compass, a lyre, a mask). Brancusi's muse is a different kind of muse – an image of perfection which unites all the muses – that's why she doesn't have a name.

She's very shiny

Sculptors work with a solid mass but also with light. They know how light will slide off a surface or be swallowed up by holes – as it has been here between the strands of hair or in the curve of the right eye. All that changes based upon where it is displayed, how it is lit and where the viewer is standing – so you get the impression that the muse's expression changes. The polished bronze creates reflections, looks like gold and even turns the muse into a kind of mirror. If you lean over her a little you can see yourself reflected in her head – nothing escapes her.

You can hardly see her eyes

It's as though the sculptor just brushed them very lightly so as not to wake her. Her slumber erases everything she doesn't need. She knows things in advance as she is made differently to you and I. She looks inward but what she sees remains a secret.

It's an unfinished face

It could either be in the middle of appearing or in the middle of disappearing, between the two ends of the spectrum like an idea that floats in the mind, appears and then disappears without ever becoming a certainty. Thought has no limits.

Why hasn't the muse got a body?

She's fast asleep so she can't feel her body. But if she had been given a body she would have just become an ordinary human being whereas this work is entirely about a spiritual being. Brancusi has kept only the important part – by choosing an element rather than the whole form he has the freedom to concentrate on a single idea with the exclusion of all the rest.

It'd be nice to touch her

The surface is smooth and the curves are gentle so it's quite natural to want to touch – or even to stroke – this sculpture. That's one of the sculptor's skills; to give you such a desire. But of course you aren't allowed to touch this sculpture as it would end up getting damaged. So she is displayed behind glass to protect her.

It looks as though she's going to roll away.

Yes, that's partly because of the simple shape and also because it looks as though she is very carefully balanced with nothing holding her in place. The muse looks as though she is at the mercy of nature, like a pebble on the beach. A large gust of wind or a wave could make her roll away. Even though she is made of hard and heavy bronze she still seems light and vulnerable.

Did Brancusi need a model?

The muse was originally a sculpture of one of Brancusi's friends, the Baronne Frachon, who had very long, fine features which Brancusi stylized. But the model was simply a point of departure as Brancusi wasn't aiming for a close resemblance. He didn't need to keep checking how accurately he was reflecting reality so there was no need to have his model sit repeatedly over a long period of time. What Brancusi wanted to capture was both a *way of being* and a *presence*. And the muse is full of both. This sculpture responds to the real world and is in dialogue with it, but is not subject to it.

How did Brancusi make it?

After having made a number of studies in clay he first sculpted *White Marble Muse* (1909) and then created a plaster mould from which he cast several bronze versions (1910). Each version differs from the other because of the sculptor's intervention: the surface contains irregularities due to the casting process. The artist enriches its unique qualities by, for example, retouching the rough cast or polishing it to a greater or lesser extent.

Why did he choose to show her asleep?

In her presence the viewer also becomes calm. According to the tradition of sacred texts sleep is often the sign of close contact with the divine. Freed from the worries of the world the sleeper is open to revelations which often come in the form of dreams or in the appearance of a supernatural visitor. Brancusi developed the idea of the muse living peacefully between two worlds – the divine and the human (whose minds she enlightens). She may seem passive but she is in fact a profound image of openness and giving.

Why is Brancusi's studio famous?

Brancusi used his workshop not just as a place to work and create but also for showing his work. Little by little it became the image of his interior world, a projection of his spirit, an oft-photographed work of art in its own right. Over the years the works would evolve, change places or disappear (some were sold) but Brancusi always maintained the balance of the whole. He even designed the pedestals for his work and they are often the ones you see in museums. Thanks to a donation by the artist his studio was actually recreated – in a small, specially designed building close to the entrance of the Pompidou Centre in Paris.

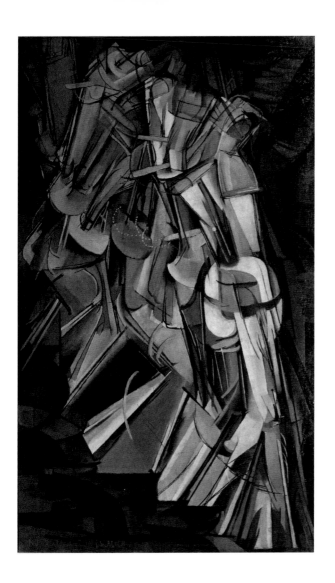

5 *Nude Descending a Staircase No. 2*

Marcel Duchamp (1887–1986)
1912
Oil on canvas
147 x 89 cm
Louise and Walter Arensburg Collection, Museum of Fine Arts, Philadelphia, USA

It's hard to make anything out

The picture seems a little complicated but it's actually of something very straightforward. Someone is coming down a staircase and the artist has captured what he can; a line here and a line there. He tries to piece it all together.

The painter didn't have many colours

He could have used all sorts of other colours but he was so focused on observing the person's movement that he wasn't really interested in the colours. But then again to construct this figure he did have to find all sorts of shades of brown – from the darkest to the lightest.

It's like a moving photograph

Not completely. In that kind of photograph the result is fluid and the picture seems blurred. In this painting though, the painter has very clearly drawn small pieces of his subject. To clearly show that it's moving he uses them like clues – thanks to them we manage to see what's going on.

It looks like more than one person

There is only one person, but to give the idea of movement the painter shows them in several different positions. Firstly at the top on the left hand side, then in the centre with two legs, two arms, then descending one step, then another and another. The painter draws the third step whilst retaining the first two so we can see where the figure was before. It makes the final picture a bit hazy. But in looking from left to right (because it's going down) you can almost see the figure move.

◊◊◊

He must be going down very fast, otherwise we'd see him more clearly

The model didn't have the time to strike a pose in between each step. At the point where they are nearly at the bottom of the stairs the artist is still looking at the top. You get the impression that it is happening very fast, but it's probably just at normal speed. There are so many elements to the picture that it appears quite busy when in actual fact not much is happening.

Why put the person on a staircase?

It makes it easier to study the movement. Going down steps means repeating the same simple movements and the staircase itself is a nicely compressed area. The treads themselves are a further advantage because they mark the regularly spaced steps on the journey. All these elements create ideal conditions for the artist to observe his model.

What's the significance of it being a nude?

Clothes would make it impossible to see the outlines of the body, hiding the bends to the limbs and thus the whole mechanism of movement. Making the figure a nude also means that you don't have to worry about defining the person. In fact we can't even tell if this nude is a man or a woman. Historically nudes were often painted to celebrate beauty – it was one of the essential subjects for artists and a means of their proving their knowledge of anatomy. With this painting Duchamp in his own way declared his indifference to the nude, as though it were a mere machine that could be taken apart.

The person could have been going *up* . . .

That's true. The effect of movement would have been just the same. But in the history of painting stairs usually have a symbolic meaning linked to religious texts (Jacob's ladder, the presentation of the Virgin at the temple). Stairs link earth and heaven and each step represents the climb towards perfection. It's the image of an interior ascent at the same time as a journey towards God. By refusing to have his model climbing stairs Duchamp affirms his rejection of tradition and brings his painting quite literally down to earth.

What are the dotted lines for?

The lines of white dots at waist-level are like 'cut-here' lines and are a reference to chronophotography. In France Etienne Jules Marey (1830–1904) and in the US Edward James Muybridge (1830–1904) had developed a technique that allowed successive phases of a motion to be captured photographically (a pelican in flight, a galloping horse, runners or indeed someone coming down a staircase). Sometimes the people photographed would be wearing all-in-one black suits with silver dots along one side to make the picture easier to interpret. Duchamp found chronophotography much more interesting than paintings in museums.

◊◊◊

Is this a Cubist painting?

It's inspired by the fragmentation of a motif: only a few significant elements are retained. A Cubist painting by Braque or Picasso would also have included heavy lines to show the places where the body makes contact with its surroundings, but would have dispensed with general outlines (which we don't see surrounding ourselves when we look in the mirror). From 1910 the impact of Cubism (1907–14) was very strong because it offered a truly new approach to reality. But by focusing on movement Duchamp allied himself rather more with Italian Futurism (1909–20) which was fascinated by technology and speed. In fact this painting defies categorization. Above all it is testament to how alive the artist was to the different trends and developments going on around him.

There aren't many famous paintings by Duchamp

That's because he only painted a very few. For him, painting was only one of a number of possible means of expression. In 1918 he abandoned painting altogether dubbing it 'retinal', that is to say, that it was only for the eyes. Duchamp was above all an intellectual. Though he moved in artistic circles in the 1920s he began to devote himself to chess – which he ended up teaching. He preferred developing mathematical strategies to pictures so the surface of the chessboard became his canvas.

It's annoying not to understand what you are looking at

That's true but Duchamp doesn't take pleasure in bamboozling his audience – although he was sometimes amused by how perplexed or exasperated people would get looking at his work. But that would only serve to confirm his theories. For him the key thing was to have the viewer ask questions about what they were seeing, rather than passively accepting what was shown. A painting like this of an everyday subject rendered almost incomprehensible by its clever treatment was good training. In 1913 most of the public was far from ready for such a thing and when first exhibited in New York it caused quite a scandal.

Why do twentieth-century artists so often refer to Duchamp?

Because he changed the way we think about art – he paid no attention to technical criteria or to the principles of beauty, spirituality or material value which were so often attached to art. In the 1910s with his 'ready-mades' (like his porcelain urinal entitled *Fountain*) he showed that an equally valid way of producing art was through the way of looking at it, the space it is given (for example in a museum) and the discussions that it provokes.

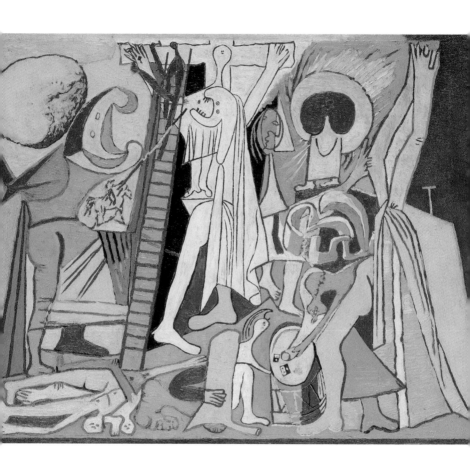

6 *The Crucifixion*

Pablo Picasso (1881–1973)
1930
Oil on laminate
51 x 66 cm
Picasso Museum, Paris, France

It's all muddled up

In this painting everyone is moving in different directions and talking at the same time. It captures a very muddled and noisy scene.

What's happening?

It's a scene described in the gospels where Jesus, condemned to death, is hung on a cross. There's a blood-red figure at the top of the ladder hammering a nail through his hand.

It's very colourful

It helps you understand how many people are there. Even if you don't understand it straight away you immediately sense how intense the colours are because they are conveying powerful emotions. Each colour speaks volumes – the red, yellow, green and blue.

It looks as though there's an earthquake

Everyone there is collapsing – Jesus's mother and her friends. Their world is being turned upside down, and nothing but little fragments remain. Picasso found this way of showing that they are losing everything that's dear to them.

There's a face with large red glasses

They're not glasses; the person has probably been crying so much that their eyes are all red. No doubt their huge head is very heavy – like when you have a headache if you are very tired. Their hair is standing up because they are afraid. But they are not about to leave.

◊◊◊

It's completely different to other crucifixion paintings

Other crucifixion paintings – the ones that had been painted for centuries – show the scene as clearly as possible. But Picasso has imagined the *atmosphere* at the crucifixion. He didn't want to show the event but to paint what you would have *felt* if you had been there rather than being calmly in a museum or reading a book. That's why you can't make anything out to start with – it's as disconcerting as a punch in the face.

How can you tell who is who?

Most of the characters are in the same positions as in the traditional paintings. Mary Magdalene is in tears right up against Christ and the tiny centurion Longin is piercing Jesus's side with his lance. In the foreground are the bodies of two criminals (thieves who were crucified on the same day) and the roman soldiers who are playing dice for Jesus's tunic. Finally on the right hand side the presence of the Virgin Mary is suggested by the raised hands and the blue veil. The figure with the red eyes might be the young Saint John.

What does the green ball represent?

The shape in the top left hand side of the painting might evoke two things; either the large stone which will be rolled in front of Jesus's tomb or maybe the sponge dipped in gall – or vinegar – which Steven the soldier will hold up to Jesus's face. It's so big because Jesus sees it close up. The choice of green is significant because it's the colour of mould as well as springtime – the painting swings between life and death.

Is that a house on the right?

Mary, the mother of Christ, symbolizes the Church which gathers together all Christians and Picasso conveys that idea by showing a little church. Her blue veil is made to seem longer by a sloped roof – like you might see on a house. We can also see the foot of the blue dress and the face of the virgin extended like a blue and white ribbon towards her son. The blue conveys the infinity and peace of heaven to several places like a caress – it appears between the rungs of the ladder, on Mary Magdalene's foot and also on one of the thieves.

What's a drum doing there?

The drum makes a noise – it's not a commonplace object in a crucifixion scene but Picasso adds it in to compound the sense of chaos. Hitting, beating, making vibrations and mutterings . . . The dice rolling on its surface make an absolute din. An everyday sound in real life becomes intolerable for someone who's suffering.

◊◊◊

Why is Jesus all white?

He's pale because he has been bleeding. But that's not the only reason. When added together all the other colours in the spectrum produce white light. The painting shows that Christ is the only one to create that unity. The tumult of the world around him is expressed through the many colours whereas he symbolizes absolute light. Whatever Jesus touches, the wood of the cross, or Mary Magdalene, is quite transformed by it. White also symbolizes the passage from one state to another. In ancient Rome students would take their exams wearing a white toga. In fact our word 'candidate' even comes from the Latin for bright white.

How can we make sense of these characters – they all seem so monstrous

That's because Picasso was following the principle of telling the truth no matter how ugly it might be. Mary Magdalene is reduced to an open screaming mouth as if all her life is in that cry. She has no strength for anything else. When pain is so raw it stops everything else from existing, it takes over everything and stops you from even thinking of anything else. Picasso had the courage to turn his back on classical forms and to show not what can be seen of another's suffering but what you can *feel* in your very soul and is impossible to share – the feeling of being ripped to shreds. The world he paints is lost in horror and his painting simply translates the atrocity of it. It's the horror that transforms the people.

Is Picasso mocking religion?

No, quite the contrary. He is a Spanish painter imbued with the Catholic tradition so it's quite natural for him to deal with such a central theme. But by giving it a human dimension he brings new life to the subject. Historically art which was designed to be didactic would focus on suffering as a route to redemption. Picasso was no longer interested in that pedagogical role but neither did he pour scorn on it. People had got so used to seeing the same subject elegantly treated that they had forgotten its meaning. Picasso sees it as a scene of torture and execution. A large crucifixion painted by Grünewald in 1516 played a key role in Picasso's work because for the first time it showed the scene in all its cruelty (it's the source of the virgin's raised arms and motif of the distorted limbs that we see here). But Picasso wanted to go further than Grünewald and show things with even more directness.

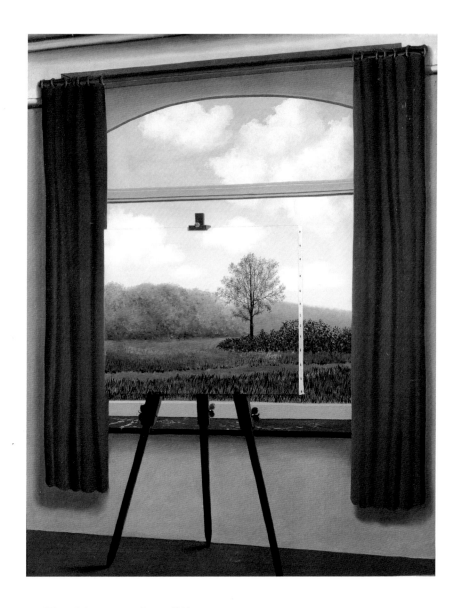

7 *The Human Condition*

Rene Magritte (1898–1967)
1933
Oil on canvas
100 x 81 cm
National Gallery of Art, Washington, USA

It's nicely painted

This artist liked his paintings to imitate reality as closely as possible. He also wanted his work to be very clean – that's why this picture is very smooth, without any discernable brushstrokes.

The window's rounded at the top

The curved shape softens the painting a little but it also makes us think of other things – the curvature of the earth or the shape of an eye for example. It's very peaceful there in front of this little corner of the landscape and thanks to the little curve detail we can see that the painter has a mass of ideas in mind.

You can look out of the window

Because the curtains are open we can see the scenery very clearly: a little path passes in front of the house, there's a small tree next to a thicket and in the distance you can see the edge of a forest. It's a very solitary place – the painter probably doesn't get many visitors.

What is that on the ground?

It's the three legs of an easel with their screws for adjusting the height. A canvas rests on the easel, held in place by the little wooden bracket at the top. On the right hand you can see the tacks fixing the canvas to its frame all down one side. On the left the canvas overlaps the edge of the curtain a little – you can see the top corner outlined against the fabric.

You can't see the real landscape

Yes, the picture placed in front of the window blocks our view of the scenery, but to the right of the canvas you can see that the little path and trees continue from where the painting ends and the clouds are even the same shape. So we can assume that the painting on its easel must be an exact depiction of what must lie behind it.

◊◊◊

Why haven't they put the painting on the wall?

Magritte wanted to show both a painting and the thing it is representing at the same time. If he had painted them side by side we could have been able to compare one against the other, but since both the images would have been the same it was simpler just to paint one.

It's not possible for a painting to be so exactly like the reality

No it's not, as Magritte well knew. But he wonders what it would be like if it *were* possible. If it *were* possible, maybe a painting could adjust to fit with nature like a piece of a jigsaw and then we wouldn't be able to tell the difference between reality and the image. For Magritte painting was, above all, about asking questions which mostly went unanswered.

Is it the window of his studio?

It's his drawing room window in front of which he would often paint. Magritte mostly painted in his apartment in a very orderly fashion. He would not let his painting take up too much space and at the end of each day he would tidy away all his things. You can see here there is nothing lying about. Maybe it's also a way of suggesting that the artist's thought process is more important than the physical creation of the paintings themselves.

Why are the curtains given such prominence?

Firstly to recreate the room accurately. We can tell from photographs of Magritte's home that he has reproduced the curtains perfectly here. Curtains also add a theatrical element – they make it clear that Magritte is unveiling something and conversely that he could equally close them up, leaving us with nothing to look at. We are privileged but at the same time reliant on the painter's good will.

Is the landscape behind the painting actually exactly as it appears on the painting?

That's a very natural question and exactly what Magritte wants us to ask, which automatically puts you on your guard. Watch out! There is no landscape other than this one here because a painting is only the image of a thing and not the thing itself. It's the illusion the painter creates that makes us believe in a reality hidden by the canvas on the easel. In real life it would be there, but here it's a trick. Beneath the layer of paint there is nothing.

Did he paint it for fun?

When you first see it you might well wonder whether Magritte painted this for fun because while it seems a very simple painting the more you look at it the more complex you realize it is. Like in a game the mystery gets deeper and deeper but in the end you see that there is no real answer. Magritte expresses his thinking through images just as others use words. He leads the viewer by the hand deep into the puzzle so that we ask questions about what we're seeing. So yes, you could say that it's for fun – but it's done very seriously.

It's as though the painted canvas was actually transparent

The window has transferred some of its transparency to the canvas – because we see the landscape through the window we also perceive the painted landscape in the same way. Magritte is recalling a very old definition which has been significant throughout the history of art. During the renaissance, the Italian architect Alberti wrote 'A painting is a window on the world.' He was suggesting that, thanks to perspective, a painting could give the impression of depth and make us forget the surface. In fact in old paintings you don't see the surface of the canvas or wood but instead you believe in a third dimension which is, of course, just an illusion.

Why is it called *The Human Condition*?

Perhaps to say that you can't really understand it, that you can't be sure of anything and that it's the nature of man to look for answers without ever reaching any certainty, or even that man is always caught in the trap of his own illusions. But it wasn't Magritte who chose the names of his paintings; he left that task to his friends – although he did of course have power of veto. But a title like this shows you the extent to which his work was aiming for more than simple storytelling.

The scenery ought to be in the sun

Yes it should. That's why he shows the shadows cast by the easel's feet. But the little canvas in front of the window is perfectly lit . . . Magritte's paintings may seem clinical in their precision and show what can be seen in almost obsessive detail but they do not actually show reality. They contain tricks and contradictions to make us think. In the end, the painter is literally saying that painting in general – as represented by the picture here – shows with clarity what in real life is far from clear. In doing so he reaffirms one of art's most important functions.

What's Surrealist about a painting like this?

Surrealism liked deliberately strange images – metamorphoses, incongruous associations between shapes, characters or situations. So it took dreams and nightmares as its subjects and gave them free rein (see Dalí, work 8). But it also took into account the difficulty, the worry or unease we can feel sometimes in the most mundane of situations. Magritte's work is Surrealist in that it shows an awareness of a gap and a slide towards chaos. Reality is there, clearly recognizable, but it is unsettled by something very profound. For him that's how the greatest of mysteries can be expressed.

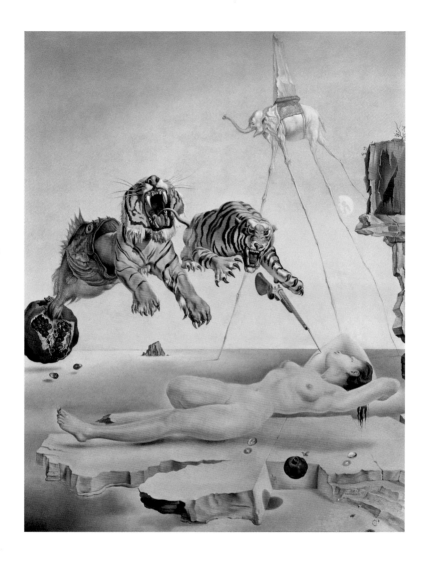

8 *Dream Caused by the Flight of a Bee Around a Pomegranate a Second Before Awakening*

Salvador Dalí (1904–89)

1944

Oil on canvas

51 x 41 cm

Thyssen-Bornemisza Collection, Madrid, Spain

Is it a circus?

There are exotic animals so it could be a circus. Roaring lions are leaping about and no one is scared. But this painting shows a dream – the dream of Dalí's wife, Gala, who has fallen asleep.

She's sleeping naked

It's by the sea so it's probably hot. She's fast asleep so she has no idea that she is being watched. Painters see a lot of naked women and Dalí is showing that he knows how to paint a woman's body – which is very difficult.

It all looks so real

Whether they are real or not both the woman and what she is dreaming are painted in the same way, with the same level of detail. The painting shows that in our dreams the most extraordinary things seem normal – even a fish spitting out a tiger!

Why hasn't she woken up?

We can tell she is about to wake up from what's happening in her dream. We even know what she's going to feel when she wakes up because we can see the bayonet blade piercing her arm. The pain is going to wake her up with a start.

You can see the moon

Sometimes you can still see the moon even once the sun has come up and it becomes paler and paler as the day goes on. Here the moon is playing hide and seek between the elephant's legs whilst the sun is lighting the horizon beneath the fish. Even though it's a violent image the light at the bottom of the painting is changing ever so gently.

◊◊◊

What's it about?

There's a bee flying next to a pomegranate but everything is transformed in Gala's dream and instead of the buzzing bee she hears the roar of the wild animals. It all starts with the pomegranate floating beside her. All the other elements are part of the same dream – a scorpion fish is leaping out of the giant pomegranate and the fish is spewing out a tiger from which a second tiger is leaping, and a bayonet. Each is a different element of the story. Finally Gala is dreaming that

the bayonet is piercing her arm and that blood is trickling down – in reality it's the bee's sting.

Tigers don't live with fish!
The dream turns the natural order of things upside down by mixing them up – fruit, fish and big cats. The artist translates Gala's train of thought, or rather the sequence of her dream, by having them spring from one another. They are disparate images and ideas which aren't normally linked in reality. And that's exactly what makes dreaming and painting so special – they make new connections between things.

It looks like one of the elephants from Dumbo
When little Dumbo is drunk (in the Disney film from 1941) he sees fantastical dancing pink elephants – they are related to this elephant here. That's not too surprising because Dalí had already been influential in the world of cinema and in fact went on to collaborate with Walt Disney some years later. He particularly liked giraffe-elephants with long, spindly legs out of proportion with the size and weight of their bodies but that could be used for walking quickly over the sea, like stilts. Anything is possible in dreams – and the more illogical the better.

The woman's body is floating
Her dream is lifting her out of the world. This is the first painting where Dalí showed someone floating. The things that exist in the artist's imagination aren't constrained by the laws of gravity. There are also two pomegranate seeds and two drops of water hanging in mid-air.

Gala is the size of a country
She is sleeping above a rocky outcrop that represents the beaches of Port Lligat in Spain, where Dalí spent his childhood. He was very fond of the area and often depicted it in his paintings. When this was painted he was living in exile in America and he must have been missing the coasts of home. So in one sense Gala became his home.

◊◊◊

You often see pomegranates in old paintings
Pomegranates often appear in pictures of the Virgin and Child or in still lifes. Because the many seeds evoke creation's bounty they symbolize fertility and the gift of God's love. Here the pomegranate symbolizes Dalí's love for Gala. The

fruit's shadow falls on the rocks in the shape of a heart folded in two. But as with any symbol, its meaning can be reversed depending on the context. This pomegranate also symbolizes deceit because though it's beautiful on the outside it is already rotten on the inside. Maybe the pomegranate is there to remind us of the difference between dreams and reality.

The tigers look like collage

That's because of the way Dalí painted them. He was inspired by photographs in a book on wild animals and by a poster for the Ringling Barnum & Bailey Circus. Using these models he made copies on sheets of transparent plastic which he then transferred to the canvas. That's not to say that he found painting difficult – on the contrary. Like many twentieth-century artists, if he liked an image he would transpose it as it was on to his paintings. In this painting the technique is simply a bonus because the collage effect just underlines the composite nature of dreams that jumble up people and situations from different places. The storybook elephant combines with Dalí's memory of a statue in a fountain in Rome which has an elephant carrying a stone obelisk on its back (sculpted by Le Bernin in the seventeenth century).

Not everyone has such wild dreams

No they don't but that's a good reason to depict this very unusual one which Gala recounted to her husband. Still, Dalí may have been less interested in the content of the dream than in its mechanics – which everyone shares. For example in your dream you may hear a persistent noise (a ringing bell or the hum of a machine) that eventually wakes you up and when you wake it seems as though the sound 'continues' in the real world – and in fact it was a phone ringing. We integrate noises like that into our dreams until we gradually wake up. Dalí is highlighting the porous border between sleep and wakefulness, between dream and reality. At first sight this painting seems full of absurdity but it shows the inevitable progress towards full consciousness.

Dreams are a Surrealist theme

Dreamland is free from society's norms and rules so it's a fundamental theme for Surrealists. In fact some Surrealists completely gave up painting representative art and focused entirely on paintings of the imaginary. As for Dalí, he favoured a more analytical approach. He adhered to strict imitative art underpinned by very pure technique. The long title illustrates his desire to describe dreams in a scientific manner. He was fascinated by Freud's writing about dreams and was even able to meet the Viennese father of psychology when he lived in London.

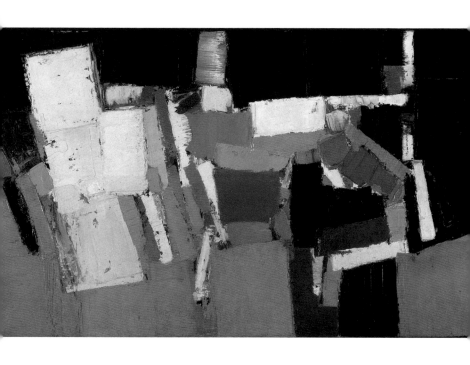

9 *Parc des Princes (the great footballers)*

Nicolas de Staël (1914–55)
1952
Oil on canvas
200 x 350 cm
Private Collection

You can't tell what it is

This painting is so big it's the size of a wall. You need a huge room to display it and when you are in front of it you have to stand well back to be able to take in the whole scene.

The blocks of colour are lopsided

The big solid colours are put on to the canvas like giant building blocks but most of them are at an angle as if they were about to tumble over. They reflect the footballers' jerky movements.

There's a lot of black

The black makes all the other colours stand out. Thanks to the black the other colours seem brighter and the painting is more impressive as a result. But of course, it's night-time. You can see bluish figures in the background because the Parc des Princes stadium in Paris is lit by floodlights.

He must have needed a big paintbrush

Paintbrushes weren't big enough so the artist invented other tools – large spatulas and a piece of metal with which he applied the paint in large blocks. They left their marks which now catch the light in the thickness of the paint.

◊◊◊

Where are the players?

They are easier to see if you step back a bit – just like with a real football match that's hard to follow if you stand too close. In the centre and to the right you can see two footballers facing each other in profile. They look a bit wooden. The one in the middle is lifting his right knee and the other is leaning forward – no doubt he is the goalkeeper. In the texture of the paint you can make out his stomach muscles and maybe the folds of his shirt. You can also see the outlines of other players to the left. They are hurrying to the edge of the painting to spread out across the pitch.

And what about the ball?

You can't really see the ball, probably because things are moving too fast – as is often the case in reality. But thanks to the players' positions we can tell the goalkeeper has just stopped it. He must have taken it right on his chest.

Why haven't they got faces?

That was the easiest way to make them universal. These aren't individuals – and certainly not today's stars – that we can recognize and name at a glance. For the painter these aren't people but geometric shapes that evolve in the space. The artist is so disinterested by the news of the day that it's even impossible to distinguish one team from another – which of course wouldn't work in a real match.

It's almost like a mosaic

Having the colour in thick chunks certainly reminds you of a mosaic. You also notice the texture of the paint as both a material and as a means of lending depth to the scene. Here it's all about the surface effect – just like with a mosaic. De Staël is joining a medieval tradition where art was used to brighten up large spaces with simple shapes, cheering those who saw them without being a distraction.

It almost looks like a landscape

The boxes of colour do evoke the patchwork of fields that you see from high up or from a plane. But that doesn't mean you can ignore what the real subject of the painting is. Nevertheless the artist does allow us some freedom. In this match – as with most things he observed – the artist saw something that others didn't see; a balance of shapes and connections between colours. This work helps us to see reality with a similar level of openness and sensitivity without allowing ourselves to get hung-up on appearances, even if it's wise to be aware of them.

It doesn't look like football

De Staël wanted to capture the essence of an evening match – the colour, the rhythm, all the things that had really struck him about it. He's not interested in describing the true details – that's for reporters. For a football fan this painting might be rather disappointing. At first sight at least that's because de Staël depicts football in a rather idealized way. In some ways he is painting the 'portrait of a match' conveying everything about it that requires strength, speed and team spirit – in other words its nobility.

◊◊◊

There's no air in this picture

You can't make out the size of what surrounds them so the scene feels very claustrophobic. It's very 'full' with each of the elements accorded the same level of importance. The artist uses the same thick paint for the air and the gaps between things as for the players themselves. Without that technique the painting would have been much less powerful. It is showing a clash so there are no 'empty' moments and no dead time. In the charged atmosphere of a match tension mounts in the stands as well as among the players, it gets hotter and hotter, people hold their breath.

Did the painter ever go to a real match?

Yes, he did go to a night-time match between France (who lost) and Sweden. It made such an impression on de Staël that he started painting that very night. It wasn't about selecting a subject in a detached manner and illustrating it in a certain way; this piece was born out of an irrepressible emotion, almost springing into being itself. This painting was the first (and largest) in a series and it led de Staël to change his whole way of working and become much more abstract. The following year he did a painting called *Les Indes Galantes* after seeing Rameau's opera-ballet. In that too the work represents the echo of a unique experience. The absence of descriptive detail – facts, people, places – can be explained by one of the central tenets of modern art: that painting does not reproduce reality but brings the invisible into sharp focus.

Did de Staël like painting themes from modern life?

Not particularly. Above all he painted landscapes, still lifes and occasionally nudes. He wasn't interested in the day-to-day or modern side of things but in what made them timeless. Painting the match at Parc des Princes was quite in keeping with that ideal; he transformed the scene into a moment of history beyond records or anecdotes. As for the way de Staël used his materials to give rough outlines – it's almost like sculpture. Like an ancient bas relief this painting captures an everyday event, a moment long since passed, and shows us something of its grandeur.

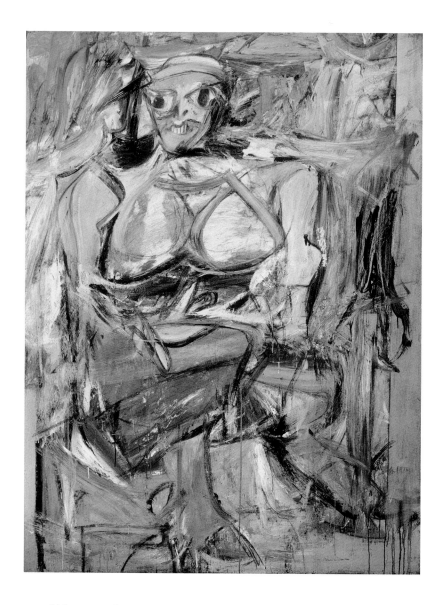

10 *Woman I*

Willem De Kooning (1904–97)
1950–52
Oil on canvas
193 x 147 cm
Museum of Modern Art, New York, USA

It's ugly

Paintings are like people – not all of them are beautiful. But that doesn't matter because when you get to know them you don't think about what they look like and you may even start to see a different kind of beauty in them. But of course, that takes a bit of time.

It's badly done

De Kooning knew how to draw very well. But it's true, in this painting he paints as though he didn't. He's asking himself what it's like to paint a picture without knowing how to. And he's saying that the result will nonetheless show all the efforts of an artist – that's what he finds interesting.

She's got big eyes and big teeth

She's got her eyes wide open and she is showing her teeth. Maybe she wants to be frightening or is frightened herself – or both at the same time. With a single grimace the artist manages to say several things at the once. Maybe he hasn't made his mind up yet either.

She's a strange character

Painting people is difficult. We forget how difficult it is because we see so many paintings, and particularly photographs, that exactly resemble the real world. But looking at this painting we are forced to think about just how difficult it is.

◊◊◊

Is she sitting down?

Seated portraits are very common in the history of art. The image frames the woman's legs so she looks more important than she would have done had it only been a bust. She is sitting down taking her time. For her, we are mere passers-by. De Kooning paints her fully face-on so she has a real authority – she seems almost majestic, like a medieval painting of Christ or the Virgin Mary. You get the impression that this is a painting of someone remarkable.

He must have been in a rush

The brushstrokes go in all directions so you get the sense that he worked any old how, but that's absolutely not the case. It's not that it's a rushed job – he couldn't leave this painting alone, he painted and painted and painted. He painted the

woman, changed her, then started all over again. He really enjoyed it and had no desire to move on to anything else. In the end he had to stop or he would never have had a finished painting to sell.

What is there all around her?

If we're to judge from the brushstrokes it's a world full of movement. You can't see where she is but the brusqueness conveys a great deal. She's certainly not sitting somewhere peaceful. Maybe the artist is evoking his workshop – a place where ideas are constantly bubbling up and paintings are continually being changed. Or maybe she is in New York, that extraordinarily vibrant city. The artist has drawn her from his imagination but he hasn't imagined a place for her – maybe she simply lives in a hubbub.

It's dirty

It may be hung in a museum but it certainly looks as though it hasn't been finished. De Kooning wants it to look as though it's still midway through being painted. He wants to show what happens when the paintbrush goes astray and when the paint runs into the corners. In real life you can't control everything either. You might paint an arm and then get into difficulties with the hand, you get one eye right and then the other goes skew-whiff. Sometimes wiping off a mark creates a different mark so the painter runs with it. A neat and tidy painting wouldn't have had any movement to it and that wouldn't have interested him.

Is it a portrait?

No, it's not a portrait because it's not of someone we can identify. It's a woman – or more exactly 'woman' as the artist named the painting. On the signs at the zoo they simply write 'giraffe' or 'bear' not 'a giraffe' or 'a bear' because it's a species that's being presented, not an individual. The animal in the cage is just one example, typical enough to provide a representative sample. Likewise De Kooning emphasized the figure's breasts so that there would be absolutely no doubt that she was 'woman'.

◊◊◊

Why would anyone paint a woman like that?

To provide an alternative to fashion. When De Kooning started work in the 1940s one of the ideals of beauty in the United States was the 'pin-up'. People would cut out pictures of young women with large eyes, dazzling smiles and attractive poses and pin them up on their walls or on the back of their cupboard doors.

Pin up girls were also to be found on postcards and calendars, in truck-drivers' cabins or on the fuselage of airplanes. 'Woman I' takes a stand against these artificial images borrowed from toothpaste advertisements. She's not about to seduce anyone; she doesn't know the meaning of the word seduction. Her heavy breasts are more maternal – like the figures in Palaeolithic art. Her huge eyes and her smile recall Mesopotamian statues (third century BC) and she certainly doesn't know how to pose, other than simply to sit there like a great stele or large upright carved slab. With this picture the artist calls into question the whole tradition of feminine idols.

Why does she have a number?

She has the number 1 because she was the first of six *Woman* paintings. There's nothing systematic about this series that De Kooning painted over a reasonably long period from June 1950 to March 1953. After two years he left *Woman 1* unfinished and embarked on three more canvases on the same subject. All four were finished around the same time in 1952. The other two followed, with slightly different poses. Exhibited together they were very much disliked by the avant-garde painters for whom abstraction was the only form of expression. As regards the numbers – that's something we see fairly frequently in twentieth-century art. It evokes the limitless possibilities and permutations in music. And woman is certainly a major theme in De Kooning's work.

So what movement does De Kooning belong to?

De Kooning didn't agree with the idea of defining an artist's style, but from his aesthetic choices and his dates we can say that he belonged to the trend towards Abstract Expressionism of which he was one of the pioneers. Originally from the Netherlands, he moved to the USA as a small child and developed a style based on the energy of the strokes and the very strong presence of his materials. This New York School included, amongst others, Franz Kline, Clyfford Still, Jackson Pollock, Ad Reinhardt, Barnett Newman and Mark Rothko. Though they took different approaches to what they painted – busy or calm, graphic or blocks of colour – they laid the foundations for an approach to painting that owed nothing to European tradition. No classical criteria could be applied to their art which was at once both primitive and sophisticated. *Woman I* represents a perfect example of combining the violence of the streets with reflection on history.

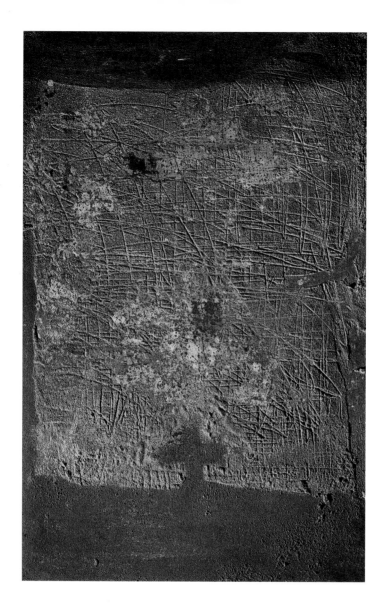

11 *Painting*

Antoni Tàpies (born 1923)
1955
Mixed media
145 x 96 cm
Museo Nacional Centro de Arte Reina Sofía, Madrid, Spain

It's all ruined!

Often the first thing people notice about this painting is what look like scratches on the surface. But that's part of the image and part of what it has to say.

It looks like cement

The painting is reddish brown and dry like a slab of mud or concrete. Even though it was done with paint it doesn't look like it. Sometimes artists decide that the usual materials aren't enough or that they could be mixed up with others that suit better: cardboard, sand or pieces of fabric. Sometimes they don't even use wood or canvas to paint on but the result is still a painting.

It's a sad picture

Dark colours aren't necessarily sad. Even for bright colours, meaning depends on the way in which they are used (van Gogh was very unhappy for instance but often painted with extremely bright colours). Here the artist has worked with materials that are simple rather than sad. It's though he only had the dirt on the ground and a stick to draw lines with, but he didn't let that prevent him from using elements we don't usually look at to create an image

There's a cross at the bottom of the painting

As soon as you notice the cross you feel a bit reassured; finally here's something familiar to hold on to. But then, at the same time there's a little doubt; it's difficult to tell whether it's a small cross close up or a large cross on a horizon. It could even just be a shadow. You don't have to choose because the painting conveys all those ideas at once.

◊◊◊

It must be very old

It's actually a rather recent piece but it's painted to look as though it's been through all sorts of trials. The artist could have painted a story, with characters, set a long time ago. But he preferred to make the painting look like an actual object from long ago – an old piece of wood, a pebble, a small item you might want to keep as a souvenir.

Maybe it's just a fragment of another picture

Even though the edges are quite straight what the picture shows does seem to belong to a larger piece. It seems incomplete. There's something missing that would explain what it is we are looking at. You might think it's a detail taken from a larger landscape or from some other work. That would be easy and it would seem to make sense. But *Painting* has always been just like this: it's a way of suggesting that painting can't say everything or show everything, it keeps and clings on to the little things.

The marks look like wounds

By simple association the marks scored in the red-brown colour remind us of dried blood and scars. The whip marks on Jesus's body on the cross used to be depicted like this. But you don't have to see this work in that light. The criss-crossed lines could also suggest a will to draw, to create a regular quadrangle, it could represent the dogged hard graft of apprenticeship. Of course it's about the idea of pain and struggle but also strength and resistance.

You sometimes see old walls like that

Yes, you will probably have seen old walls a bit like this, in towns or in the countryside. Even if they aren't exactly the same they belong to the same family – the family of stones which survive no matter what. This work is very close to real life. The artist is all the more interested in the link between painting and mural because his name, Tàpies, means 'wall' in Catalan.

Why make a painting look like something that's been damaged?

The aim is to evoke the idea of the past. The work presents itself like an archaeological find – a shard of pottery or even a fossil. Standing in front of it, you must admit that it takes patience to understand some things. This work speaks of a long story; of the long life the artist lived to get to the point where he could paint this. It's as though he were saying 'I've travelled far and worked a long time. I've forgotten many things along the way and I've also aged. This is what I have to show. This is what I have become.' And that is unique.

◊◊◊

Does the cross mean that it's a Christian painting?

No, it's not an illustration of a specific religious subject. But the painter comes from a Christian tradition and can't use a symbol like that without knowing that it will provoke a certain reaction. The cross definitely adds religious resonance to the painting. It evokes other images of the simple crucifix in the twilight at Golgotha. But more than being the representation of an object, here it's a sign from a time *before* Christianity that marks, for example, the first division of a space, the crossing of two paths. Every cross is a crossroads and a point for making choices. In this way the artist is recalling the beginning of History – the possibility of changing everything by taking a different path. At the same time he is affirming the reality of his own life because the shape of the cross is also a letter T, his wife Teresa's initial, and of course also the initial of his own name, Tàpies. With that he also paradoxically makes a connection to the poor and uneducated who, not knowing how to write, must sign their names with a cross.

What's the connection between this painting and traditional painting?

It's a very natural connection. What gave paintings of past centuries their expressive power was not only the representation of nature but the means they used – the use of colour, the surface and texture effects that play with opacity or transparency, the combinations of light and shadow. Everything that was once at the service of an image here is enough to create an image alone. The earthy and charcoal tones that we see here recall the work of Zurbarán or Murillo in the seventeenth century though gone are the saints dressed in habits and the beggars in rags meditating on the brevity of life. Tàpies's work speaks the same language but gets straight to the point – showing the destitution, the weight of material, the solitude of a place when the traces of those who were once there start to fade. In fact with a picture like this you start to 'enter' the reality described in those historical paintings – it is as though you become a saint or a beggar.

Why did he call it *Painting*?

It might seem surprising because it's obviously a painting, but of course the title is not very useful because it doesn't provide any information about the image itself. It's actually a name – not so much a title – that was fairly popular in the twentieth century and confirms the independence of the work. It's not a painting 'of' something but simply 'painting' in the sense of a presence, the materials and the act of the artist. Between the four sides of the frame this picture celebrates its own existence and creates a space for reflection on the world.

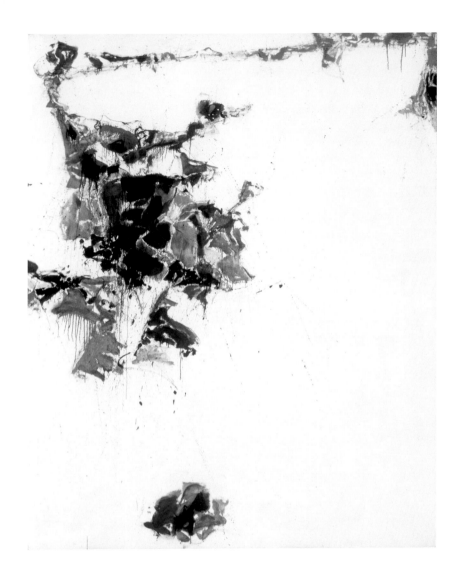

12 *The Whiteness of the Whale*

Sam Francis (1923–94)
1957
Oil on canvas
265 x 218 cm
Albright Knox Art Gallery, Buffalo, USA

The colours are running

Yes, it's a painting that gives the impression of being liquid. The painter wants to give the idea of water, the sea, extraordinary light . . . of something that even the painting can't contain.

There's paint missing

Normally paint covers the whole canvas but here the artist needed a lot of white. Most whales are grey and he wanted to show a very rare, white one. He wanted the viewer to be dazzled. Since the canvas was already white it wasn't worth adding any more.

Where's the whale?

Who knows! Its colour fills the painting and we can sense its presence – maybe even very close. You can look for it but you can't see it. You can imagine how a sailor who has spent his whole life looking for one would feel.

Are there people we can make out?

Like with clouds, if you look closely you think you might be able to make out some profiles, a duck, or a rabbit. Like the sailor searching the horizon for a glimpse of his whale, if you wait and look long enough you find something because you want to. But they are only outlines created by our imagination.

The artist must have thrown paint at the canvas

Sam Francis worked with large paintbrushes and normal brushes too. Sometimes he applied the paint with such force that it would split the canvas and other times he would let the paint run a little to create unexpected shapes. As a result the painting is like the wind over the sea – sometimes calm and sometimes stormy.

◊◊◊

Why can't you see the sea?

It's not a traditional seascape. The painter wasn't interested in depicting a particular place. Above all he wanted to give the viewer the feeling of being at sea. There are no fixed points, everything is swaying. Gusts of colour blow across the canvas and you get soaked by a wave. You haven't got time to look into the distance and certainly no time for thinking.

Did the painter really go whaling?

No, this painting isn't about his personal experience but when Sam Francis was very young he read and was fascinated by the Herman Melville novel *Moby Dick* (1851). The book tells the terrible tale of Captain Ahab who is obsessed by Moby Dick, the killer whale which once tore off his leg. The title of this painting is the title of one of the chapters in *Moby Dick*. When Sam Francis painted this in 1956 the film adaptation of the novel had just been released. It may be that the John Houston film re-awoke the memory of the book Francis had read as a child.

Was this painted on a boat?

During the impressionist era some paintings were done on boats so that the painter could be surrounded by his subject. But this painting was actually done in a studio in New York. The movements of the paint translate the movement of the boat very well, so Francis didn't need a real boat to rock his painting. But this was a technique that he often used, even for subjects with no connection to the sea. His idea of painting was that it should float, slip and glide – we don't know if it will wash us away or leave us behind.

It's a sort of kaleidoscope

Yes, but a broken kaleidoscope. The colours are all muddled up – some have run off the canvas and others haven't yet arrived. In fact the canvas is not certain to be able to hold on to them all. Eventually the painting gives up trying to keep them in order and accepts their moving about as they wish. There is pitching and rolling, the painting is constantly being knocked over. Maybe it's the whale that's going to send everything flying.

There are some little marks on the white

To start with all you notice is the white and everything looks very simple, then you soon discover little drops of colour exploding across the canvas and meaning it can never be fully at rest. When he got carried away the artist compared his paintbrush to a harpoon – so are they drops of water or drops of blood?

◊◊◊

The canvas looks a bit empty

Yes, here space is more important than shape – shapes are only transitory, whereas an empty canvas is absolute. The only way to have conceived of this canvas was in motion (because of the impossibility of stopping the course of

nature). So this is a pathway rather than a picture of a conclusion. The colours merge and separate on the canvas like beings coming to life and dying. Sam Francis recalls the immensity of the sky and the sea – the terrible gulf capable of swallowing everything – and that finally swallows Ahab's boat and crew at the end of the story. The whiteness is at once the white of the whale, the white of the sail and the symbol of the invisible world, the hereafter.

Could you say that it's a literary painting?

Not at all. Being inspired by a novel isn't enough to make this a literary painting. To gain that label there would have to be some sort of illustration of a narrative – which is quite at odds with the way Sam Francis was working. Melville's text is more of a jumping off point for him. It's a catalyst for the mind of the painter who has held the memory of the story since childhood. Its main themes are vengeance, courage, cruelty and reflections on human nature which in the end are larger than the events described in the book.

Can a painting be abstract if its title describes something?

That's often the case. A painting's interest lies precisely in the distance between what is said and what is shown: here the hunt for the whale whose whiteness also suggests its absence. Sometimes abstraction can highlight a particular theoretical angle or the title of a work might list the pure geometric shapes. For artists like Sam Francis it's a way of translating a collection of natural feelings. The title doesn't describe the image but is fundamental because it indicates what inspired it.

Is it true that Sam Francis was influenced by Monet?

It depends what you mean by 'influenced'. It would be more accurate to say that for Francis, knowing Monet confirmed his own research. This work was produced when he had just spent seven years in France. In 1953 he had been able to see *Water Lilies* at the Orangerie des Tuilleries museum though it had been closed to the public since 1950. At he time, Monet's work was not nearly as well appreciated as it is now. For Sam Francis and other painters like Ellsworth Kelly or Joan Mitchell it was a fundamental discovery because here was a painter using the experience of a huge space in which the viewer could lose themselves; a place where every shape, or line of colour had sprung from the hand of the artist.

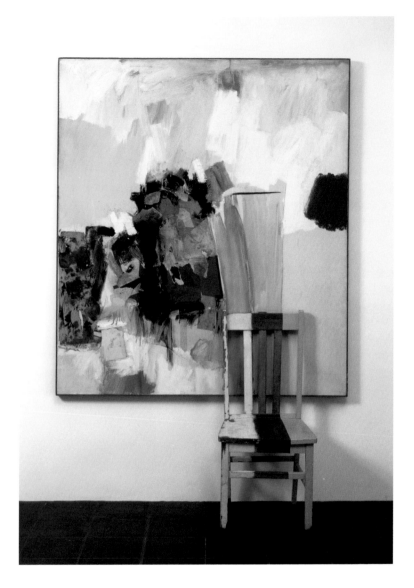

13 *Pilgrim*

Robert Rauschenberg (1925–2008)
1960
Oil on canvas, collage on paper and fabric, varnish on wood
201 x 137 x 48 cm
Kunsthalle, Hamburg, Germany

There's a chair in front of the painting

Placed exactly where the painter wanted it, the chair is part of the work. A painting-chair or a chair-painting – they go together.

That's useful

Yes. Visitors to museums sometimes feel tired. In his own way the painter is saying 'I know you've been on your feet for a while, have a rest.' Or even 'Hey you! Don't go so fast, look, here I am! Take a seat for a minute . . .'. You are actually not allowed to sit down on the chair but the thought is there.

There are also pieces of paper stuck to the canvas

Under the paint you can see the outlines of torn pieces of paper – little pieces that have been kept or have been peeled off. This work includes everything – it allows traces of what was there before to remain visible because that's just the way the artist wanted it.

You can see the sky

Because it's at the top of the painting the blue certainly does evoke the sky. So you get the feeling that you are looking at a landscape in fair weather. The brown shapes could be the roofs of houses or fields or something else altogether. By placing the blocks of colour in this way the artist allows us the freedom to build our own image.

◊◊◊

Maybe he didn't know how to paint a chair so he used a real one?

Robert Rauschenberg certainly did know how to paint a chair, but a real one was even better. After all, no one sits down on *painting* of a chair do they? Adding a real object was much more exciting. Maybe no one wanted that chair anymore and now it's been turned into something very important. Maybe before it became part of a piece of art, people would sit on the chair without paying it the least bit of attention. Now, people look at it properly. It's the artist's job to mix up the order of things.

He tried several sample colours

The stripes of colour next to each other or overlapping are reminiscent of a building site where the colours haven't yet been decided on. People try out different combinations and proportions. With a palette full of sample colours you can imagine a huge number of combinations, each of which creates a different atmosphere and in the end you have to make your mind up. But this painting is happy just to present the different possibilities. Rauschenberg leaves things open. That doesn't mean that this is an unfinished painting but rather that the painting itself is a place where everything will always be possible.

He could have chosen a more beautiful chair

If he had chosen a beautiful chair it would have been noteworthy before he even used it and no one would have been surprised to have seen it in a museum. The important thing is that the artist chose a very boring, everyday chair and by changing its context transformed its destiny. For that to work the chair had to be anonymous – with no particular style or value. It had to look as though it could belong to anyone and that it could have come from anyone's kitchen – then anyone could imagine it in their own home.

Why are there three colours on the chair?

It looks as though something is happening to the chair. Caught up in the dynamics of the painting, the chair too gets its own colours. The three stripes, white, yellow and brown, correspond to what's happening on the painting itself, though the colours are softer. There's no need to fix the chair to the wall because you can clearly see that the painting has it pinned down.

Above the chair the painting is different

The position of the chair corresponds to a change on the canvas. If you look at the composition from left to right (as Westerners read text) it also marks the end of an arc. First of all the colours are pressed up against one another, mingling and jostling for position, then the strokes become simpler and the paint falls in bands of blue-grey and beige, spreading out above the chair like a kind of waterfall. The picture starts out very tumultuous and then calms right down. It might have become so calm as to even fall asleep if Rauschenberg hadn't included an explosion of red like a jolt at the end. It's a story with pace, peace and humour.

◊◊◊

If you did sit down you wouldn't be able to see the painting

This work isn't asking the viewer to forget about real life. Rather, it hopes to help us see life with more freedom, attention and imagination. Once you've looked at it you can turn back around to the real world and perhaps discover a new energy or new shapes you'd never noticed before. You can read this installation in several ways but when it was first displayed in France in 1961 many people were shocked, thinking that Rauschenberg was turning his back on the American art of the time. But all he was doing was adding a real object to a painting – without in any way abandoning his work with canvas and brush.

Who is the pilgrim?

The pilgrim is someone who's not there – or at least not yet; the passer-by, the one who's welcomed and offered a seat. The one you ask about what they've seen or off to see next, because they may not return from their next journey. It's someone who's been wandering through the museum, someone who stops and looks, and someone who wants to hurry home, the curious person, the wise or the fool, the one who forgets where they've been but knows it was important.

Why a chair?

It's one of the most common and useful of everyday objects; we all use them. The chair automatically makes the painting accessible. Chairs feature as a motif in lots of paintings. Van Gogh painted Gauguin's empty chair after he left Provence. In 1965 Joseph Kosuth, a conceptual artist, created *One and Three Chair:* with an ordinary chair, a photo of it and a text that describes it, each element of the work completing or modifing the others. In 1984 Antoni Tàpies designed a spindly chair set in steel and aluminium clouds to crown the façade of his foundation in Barcelona. As a symbol of waiting and availability, the empty chair already had a place in Hebrew tradition: the custom is that a place is always left free at the table for the prophet Elijah.

Is it a painting or a sculpture?

It's just a collection – or more precisely a 'combine', as Rauschenberg called it. Rauschenberg would make his combines from a wide selection of objects and materials but he always attached great importance to the painting element. These works fill the space in quite a different way to paintings and sculptures. In 1954 the choreographer Merce Cunningham even incorporated the first of Rauschenberg's combines, *Minutiae*, into one of his ballets.

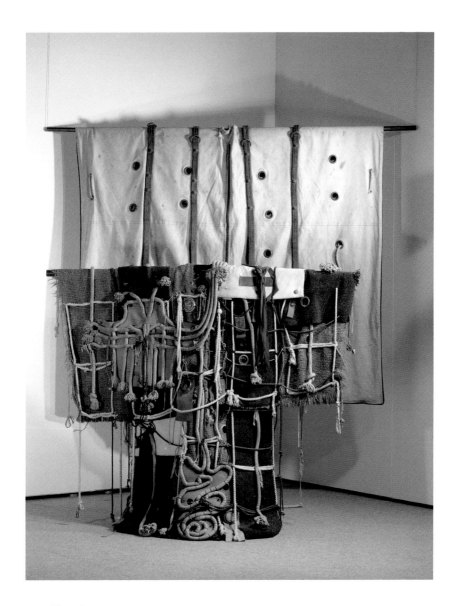

14 Coat

Étienne Martin (1913–95)
1962
Fabric, trimmings, ropes, leather, metal, tarpaulin and leather wrapping
250 x 230 x 75 cm
Pompidou Centre, National Museum of Modern Art, Paris, France

There are two objects

The main part of the work is the colourful piece in front. It's a coat. Behind it is much lighter-coloured wrapping. They are always exhibited together.

Is it fabric?

Yes, it is, like all coats, even though this one is more of a sculpture in the form of a coat. The artist made it from all sorts of different coloured fabrics – some of them coarse and thick like door-matting and others as light as summer scarves. Some of the fabric is scattered with little flowers and there are even pieces of coquettish lace. The wrapping is in very stiff fabric with zips and leather straps to close it all up.

It doesn't exactly look like a coat

It's very complicated – more than a mere coat, it's a whole story in itself. The pieces of fabric, the ropes, the bits of leather and the metal eyes all recall the artist's childhood memories – for him it's like a magical talisman, protecting all his secrets.

Is the back as highly decorated?

Yes both sides are decorated in the same way, but the pieces of fabric and leather are placed differently and are different colours. For example on one side there is a blue scarf and a red scarf and on the other side there is green scarf. You have to walk around the work to see all of it.

◊◊◊

Can you wear it?

No. It's not made to be worn – it would be too heavy. But Étienne Martin was very fond of it and on special occasions he would put it on, for just long enough to be photographed in it. That brought the coat to life. Now that the artist is no longer alive it is a museum piece displayed alone.

What are the ropes for?

They serve the same purpose here as they always do – they attach, they link, they divide, they hold together and all sorts of other things as well! The coat summarizes all the different uses you can think of and each one takes you somewhere different – on a boat, to the middle of the countryside, to a loft or cellar – wherever you need ropes and links to guide animals, to tie up a load or even to lift a curtain. It's an infinite voyage taking place before our very eyes.

It looks like there are ladders all over it

Circus acrobats use rope ladders which demand huge agility. It's the same idea here. The ropes let you climb from one idea to another, they help you across and climb higher still. They draw geometric patterns on the surface of the coat like the plans for a town or a house. Each little rectangle is a room where you can make yourself comfortable. And if you wanted to leave or just to hide once you are at the top, it's much easier to pull up a rope ladder behind you than a staircase!

The ropes remind me of entrails

In the middle towards the bottom of the coat the ropes coil around themselves like intestines. The more you look at it the more the coat seems to resemble a person. It started out looking so robust and then it takes on the appearance of someone who's been flayed – exposing everything that's inside them, everything they've swallowed or digested over the years. It's a very simple way of evoking what they have lived through; the feelings and emotions that have been buried. Sometimes we say that if someone is very nervous they have 'knots in their stomach' and this coat certainly knows what that feels like!

It's like a wizard's costume

It is mysterious because we don't know what all the elements, so carefully assembled, are for. It's like watching someone making a clear sequence of very precise movements without knowing why. You assume that it's something to do with some exotic ceremony. Some see this as a kind of kimono because the way it is presented is reminiscent of the traditional Japanese formal garments. But metaphorically speaking this comes from somewhere else. Like all artists, Étienne Martin was a kind of magician – he had the power to create objects that defied the rational world.

◊◊◊

Why is the wrapping part of the work?

The dialogue between the two elements enhances the meaning of the piece. The wrapping suggests the idea that the coat itself needs to be protected, making it seem both more vulnerable and more valuable. The light, uniform colour forms a kind of skin to cover all the variation inside. Set slightly back from the coat, it appears like a kind of modest reflection, like a servant behind its master. But being placed slightly higher it is also reassuring – it's ready to descend on the coat like a cloud. It's almost as though we are waiting for the wrapping to make the coat disappear, for it to close like a curtain on the small theatre that is the coat.

What's the difference between this coat and a designer's model?

You may well ask because the medium here owes much more to the world of fashion than it does to the world of sculpture. With this coat Étienne Martin created the first fabric sculpture. The main difference is what the work was designed *for*. This coat was never meant to be worn by anyone – not even a model on a catwalk – neither was it meant to provide a template or a guide to the world of fashion. It was never thought of as something useful – even though in the end it is very useful on a symbolic level – nourishing the soul and the imagination of those that see it . . . On the other hand, certain fashion designers were inspired by its finds and popularized a number of its colour and texture combinations.

What are the *Demeures* by Étienne Martin?

Demeures is the name Étienne Martin gave to a series of works which he started in 1954. *Coat* is part of that series, which also includes other pieces in very varied formats and media including wood, stone or iron. With them, the sculptor gradually created an entirely autobiographical parallel universe which brought back to life his long-lost childhood home. Each sculpture constituted a return to that place which he discovered, explored and experienced as a child, inventing delightful little rituals as he went. Here's a skylight, there's a staircase, a terrace, a spot where you have to jump two steps at a time or somewhere else where you have to hop. *Coat* was built on those foundations, made increasingly solid as time passed and more and more memory was required to recall them. With its splendid fabric, horsehair and lace, metal and frills, it was as painstakingly constructed as a birds nest.

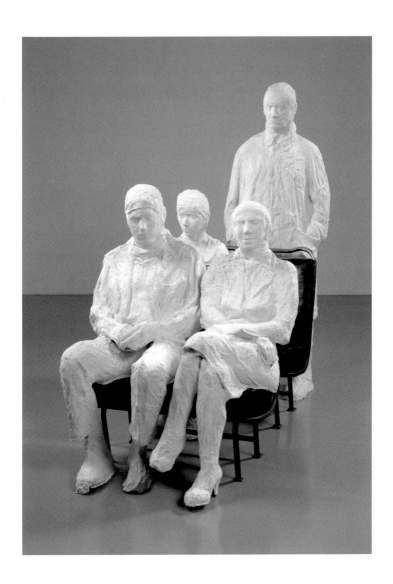

15 *Bus Riders*

George Segal (1924–2000)
1962
Plastic, cotton, gauze, leather, vinyl, steel and wood
178 x 108 x 230 cm
Smithsonian Institute, gift of Joseph H Hirshhorn 1966, Hirshhorn Museum and
Sculpture Garden, Washington DC, USA

They are all white

They are plaster figures: a man and a woman on the same seat and a young girl behind them. At the back there is a man standing with his hands in his pockets. The sculptor could have coloured them but he chose to leave them all white, so they all have something in common, even if they are physically quite different.

Is it a family?

Maybe, we don't know. They are next to each other on a bus but there is nothing to tell us whether they arrived there together or even whether they know one another. They aren't looking at each other or speaking to each other and they aren't touching. They are just ordinary people like we see every day.

They don't look very happy

When people take public transport they often appear rather vacant. They are focused in on themselves. Sometimes if we aren't being watched we can have a lack of expression that makes our features appear rather hard. It simply means that their faces are still and at that moment nothing in particular is happening.

Why are they on real seats?

It's the real seats that connect these people to reality. They look like real people sitting on a bus rather than statues in a museum. So they are not so very different to you or I.

◊◊◊

Maybe they're ghosts

If the stories are to believed, ghosts come back to haunt the living but they are only spirits, whereas these people appear to be solid. They aren't paying any attention to us, they are happy to go about their everyday business, dressed in everyday clothes and in an everyday situation. Maybe the white that's covering them simply represents the sculptor's gaze that has touched them.

What are they looking at?

No doubt they aren't looking at anything in particular. They are staring into space while they wait for their stop. You can imagine what they might really be seeing if you picture yourself on a bus – roads or shops. They don't seem interested in what's outside, the work is not set anywhere in particular and the sculptor didn't

include any background – we don't even know what side the windows are on. Since we can't see their eyes we have the impression that they can't see.

Why isn't the man sitting down?

Having the man standing up makes the scene more realistic and varied. Four seated figures would have made a very compact and monotonous mass and would have given the piece a very different feel. There is a place free but the man prefers to stand apart from the group. It shows a certain way of being, an independence. Although on the other hand, someone might just have got off the bus, leaving an empty seat. If you imagine that's just happened you notice some further details – the woman lifts her chin a little, the young woman turns away slightly while the seated man remains lost in his own thoughts with his hands crossed – maybe he is worrying about something.

They don't look like the normal kind of statues you find in museums

That's because they are of normal people. Everything about them is normal – their clothes, their expressions, where they are and how they are holding themselves. We know nothing about them – not even their names, whereas the ancient sculptures always depicted historically significant individuals or characters from stories whose particular qualities the artist wanted to highlight. That's not the case here. These statues are so close to reality that they look like actual people imitating statues. They make you think of those street performers who cover themselves from head to foot in white or gold and stand motionless for hours, pretending to be marble statues or mummies in their sarcophagi. Segal's sculptures look like real people turned to stone.

How are they made?

They are made using moulds taken directly from models that the artist then covers in bandages and soaks in plaster. He tested this process on himself first. It allows the artist to capture an exact likeness instead of something which might only be more or less accurate. There is almost no difference between the model and the result. In the 1970s Segal modified the technique and started to work on the insides of objects which themselves became the moulds. A little later still he started adding colour.

◊◊◊

Is modelling really sculpture?

Not strictly speaking, no. But modelling is a stage in the creation of bronze and other metal sculpture. A clay model is used to create a mould and the chosen material is poured into the empty shape obtained. Elsewhere there is a long tradition of moulding funeral masks from the face of the deceased, so as to preserve a final image in death. So in the past it was a practice reserved for very specific circumstances with very specific processes. In 1877 Rodin exhibited a bronze sculpture of such anatomical accuracy that critics wrongly accused him of having taken a mould from a model for his *Age d'Airain*. At that time, as far as the sculptor was concerned, there could be no worse accusation. By the twentieth century that was no longer the case and mould making – not to be confused with traditional sculpture – is accepted as just another way of creating three dimensional work.

Why use plaster?

Well firstly because it hardens very quickly – which is a great advantage for the artist, but also because it has some very specific associations. If someone is 'in plaster' it's because they have broken something. We know that hidden under the plaster there is an injury which will eventually heal and leave a scar. Even if the person is no longer in pain, the plaster is a kind of visible symbol of the pain he or she will have felt when the injury was caused. Segal's figures were completely covered in the thick, lumpy white plaster – they have it on their mouths and in their eyes as though they belong to a broken human race that the artist has to mend.

This work isn't saying anything

It is – but it's a silent story, a story we can only guess at. It's the story of the ideas that come and go in the minds of the figures here. It's the story suggested by little movements on the surface of the plaster, just as it would be by the strokes of a painter's brush – little subconscious hints that come from the movements of the sculptor rather than the subjects themselves. Something happened to numb them, fix them there once and for all. It seems as though they are suspended in time. In their New York bus Segal's figures are little different from the citizens of Pompeii who were caught by an eruption of Mount Vesuvius in the first century BC and whose figures we now have preserved in lava. They too, like any living being, were simply 'passengers'.

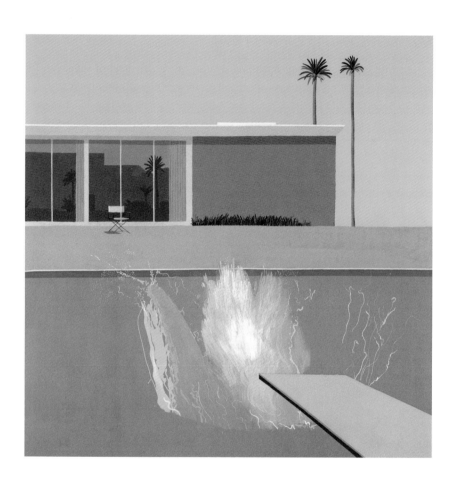

16 *A Bigger Splash*

David Hockney (born 1937)
1967
Acrylic on canvas
234 x 244 cm
Tate Gallery, London, England

I can hear it go splash!

That's exactly what this painting is about – the movement and above all the noise that goes with it. It *is* a splash!

There isn't anyone in the painting

The only person there is now in the water. They've just dived in and the water is still mid-splash. We got there too late to see them, or we were looking the other way and missed it.

You can't see anything in the water

Even if you look into the water you can't see anything. It's too soon as everything is still hidden by the splash. The pool must be very deep. You realize also that the painter didn't want to show the water as transparent or reflective, preferring instead to show it as completely opaque.

It's a very big swimming pool

It looks all the bigger because we can't see the edges in the painting. It seems as though the pool is limitless, even if you know that's not possible. You get the feeling of being in a huge open space, which is much nicer than somewhere where you are crammed up close to the neighbours. David Hockney liked painting pleasant images that make the viewer feel relaxed.

It's well drawn

Hockney worked with a lot of precision, using a roller so that the surfaces of his paintings are lovely and smooth. He even used strips of tape to make sure the edges where two colours meet each other are sharply defined. The lack of distracting details also helps the scene to feel very calm.

◊◊◊

You can see other buildings in the reflection in the background

This detail proves that David Hockney was perfectly capable of painting reflections even though he didn't paint any in the pool. Here, he used them to suggest the surrounding villas, like the one in the painting. The buildings must belong to pretty rich people. The large windows of the house let you imagine the amazing views they must have, but they don't give anything away about the interior of the house. This is a world protected from prying eyes.

Someone's put a chair by the pool

If the chair wasn't there, we might think the diver was an intruder. But the chair lets us know the house is lived in. It's a folding 'director's chair' which might suggest that the artist is directing his painting like a director does a film. Hockney is letting us know that there is an element of fantasy here – that's it's 'make-believe'.

Where is it?

There's a blue sky, palm trees and a swimming pool – so it's somewhere that's sunny all year round . . . The scene immediately suggests California in the USA. Maybe it's southern California, not far from Hollywood, where the big film studios are. Hockney had discovered Los Angeles four years earlier and he liked it so much that he returned there every year.

Why didn't he include any people?

The painting welcomes us in and we immediately feel at home because there is no-one else around. It's like going into an empty home or a hotel room. Even the invisible diver seems to invite us to follow them into the water. In fact, the viewer is the real character in this picture.

It all looks brand new

The lack of any surface texture conveys the sense of a clean, brand new place. The picture doesn't have any trace of the past about it – no memories. It's a bit like in cartoons, Hockney is showing us a world where everything is in its right place and nothing grows old. It's an image of an ultramodern paradise.

It looks like an advert

Yes. In actual fact Hockney was inspired by the photo in a swimming pool advertisement, which explains why the image is so impersonal – because the advert needed to appeal to the broadest possible audience. The clear composition is easy to grasp even if you don't have lots of time and you get the impression of somewhere where life is simple. That in itself is enough to suggest the idea of holidays – in fact, it's rather like a holiday advert.

◊◊◊

Swimming pools are Hockney's favourite subject

Not at all! He only did about ten swimming pool paintings, whereas he painted many more landscapes and portraits. But his swimming pools – starting from 1964 – were so successful that they are the ones that have been reproduced the most often. People have ended up thinking that's all he ever painted which is a vast oversimplification of his work. They sum up a certain lifestyle so well that they have become a kind of cliché. Even though they depict a cold, flat, sterile world they also convey how seductive contemporary life can be: it's 'clean', efficient and washes away all our daily troubles just like water would wash away Hockney's acrylic paint.

A splash isn't an everyday subject

In choosing this subject David Hockney joins an ancient tradition dating back to the Italian Renaissance. Artists back then were very interested in painting the impossible – things that were too quick, blinding or intangible to paint – like thunder and lightning. By painting storms, blazes and fireworks Giorgione in the sixteenth century and Turner or Whistler in the nineteenth century rose to the challenge that had already been lain down in ancient texts. This splash is a worthy successor to all of these natural phenomena by which the old masters measured their painting skill. Hockney was inspired by the artistry and technique of his predecessors and said he also loved the idea that he'd taken two weeks to paint something that only lasted two seconds.

The splash contrasts with the rest of the painting

It's the only part of the painting to show any motion; the exception in an otherwise untroubled surface. The year before *A Bigger Splash* Hockney had painted *The Little Splash* and *The Splash*. At the time he was neighbours with another painter, Ron Davis. Davis painted in abstract geometric style and he and Hockney would often discuss their respective visions whilst playing draughts together. This picture could represent their shared pastimes with the checkerboard symbolizing the space of the canvas. First of all Davis seems to be in control of the game – his arguments seem to be winning through with the composition of the painting following a strict and austere geometry. But then Hockney takes the upper hand and finishes with humour – suggesting the chance of an intrusion on the strictly controlled reality; he adds the dive! Hockney's splash is in some ways a kind of theoretical statement, accompanied by a laugh.

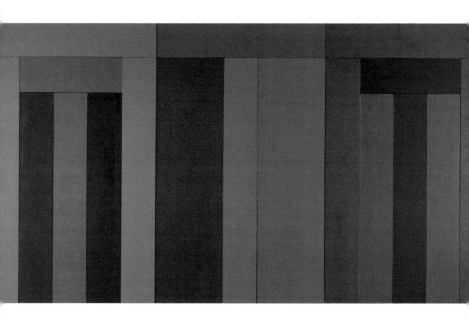

17 *Thira*

Brice Marden (born 1938)
1979–80
Oil and beeswax on canvas, 18 panels
244 x 460 cm
Pompidou Centre, National Museum of Modern Art, Paris, France

Are they big doors?

No. They're just door shapes, you can't open them. But the artist uses them to give us the idea that his painting has things to hide . . .

There's more than one painting

Yes, eighteen different panels had to be combined to make such a big work of art. It's called a polyptych. They used to do the same thing with religious paintings of Christ, the Madonna and Child or of the saints.

Each of the paintings is a bit different to the others

Originally this artist's paintings were all one colour. Later on he wanted to display them all together with different nuances and formats. He chose his colours very carefully like a mason choses his stone: when nothing is left to chance he knows the work will hold its own and he has made something harmonious.

It's like a game

Yes, it's a bit like a huge building game – the shapes are very simple and there is no fixed way for them to fit together. It's the way the painter has put them together that suggests doors, windows or something else . . . just like Lego. But there's one difference: Lego is all about building and then taking apart what you've built so as to make something else. This painting has been constructed once and for all. It's finished.

◊◊◊

It can't have taken very long to do

On the contrary, a painting like this comes together very slowly. The painter isn't following a set pattern but is making his painting up as he goes along. He gets rid of some shapes that he may have thought would be needed at the beginning. When it's finished only the essential elements remain and may not be what he had expected at the beginning. He has to reach the point where he is satisfied and a little bit surprised at the same time. It's a very personal thing and it can sometimes take quite a long time.

You can see three main parts

At first you see one large piece, then you realize that the artist has organized the three parts so that there is a very clear relationship between them. The shape of the three Ts is also a way of creating a kind of hierarchy between the centre and the two side panels. The largest, the dominant one, is in the middle with the blue bar leading up to the red band at the top. The two others on the sides are one band lower down.

Is it the outside of a palace?

It's not exactly a depiction of a palace, but this painting can certainly give you the same feeling as you would have standing outside one. You look for an entrance, wonder whether it's possible to go in, or even whether it's allowed. Of course you wonder what this place is, what it's for, who owns it and what's inside. Normally you might wonder about what a painting is showing but in this case, before you even know what this painting is called, its references to architecture make it quite clear that it is meant to take you beyond itself . . .

What does the title *Thira* mean?

It's the official name of the Island of Santorini. Since the early 1970s Brice Marden had enjoyed travelling in Greece. Thira (or Thera) evokes a glowing landscape full of warm colours and of course the ancient culture. Recent archaeological digs have revealed a very advanced civilization – multi-storey buildings, beautiful stonework . . . Another very similar Greek word, *thyra*, means 'door'. In one single word the artist evokes a land, a place and its associated myth. This polyptych hints at the palace of Knossos which housed the minotaur of legend. If the title suggests the outside of the palace, then the closely fitting shapes reflect Theseus's journey through the labyrinth.

Why did the artist focus on the letter T?

For several connected reasons. Firstly a T is a tool used by architects when they are doing technical drawings. In the shape of a T – with no graduation, unlike a ruler – it can be used to draw long straight lines. The areas coloured as Ts also depict the most basic of constructions; the vertical pillar with the horizontal lintel. And of course T is the initial in Thira and Thyra. The same letter also reflects the Taw, the final letter of the Hebrew alphabet. So the T is laden with symbolism, it's a tool and a letter, the beginning and the end of a text, a space and a story . . .

◊◊◊

So is there a connection with the tradition of polyptychs?

Yes. This is a contemporary version: the general rhythm and the way the shapes are put together might remind you of the way you have seen the crucifixion depicted on a page. But it's no longer a question of showing people or telling a story. The viewer is alone before a painting which invites them to reflect without relying on a particular place or particular faces. There is nothing to make you focus on one specific moment in history – your thoughts are free to go where they will, all depending on how you see the painting – whether as an undefiled space, where nothing has yet appeared or on the contrary as a place which has been deserted. You're looking at the beginning of a story and its conclusion and in so doing you discover that absence is a key theme in twentieth-century art.

This painting refers both to religion and mythology

Nothing new there, they did just the same in the Renaissance – except that back then they would borrow structures from the ancient tales in order to focus attention on truly Christian meanings. Appropriated motifs could also be turned on their heads; for example they would paint an arc de triomphe – originally a symbol of victory for a Roman general – but in a context where it would symbolize the victory of Christianity over paganism. This system of spiritual hierarchy no longer exists in twentieth-century art. Piling references on top of each other is a way of reinforcing a common idea and expressing intellectual harmony. The hope of life after death, escaping the labyrinth, waiting before a closed door . . . all those images within a single work have exactly the same effect of supporting the artist's meditation.

Is the door a symbol?

It's a shape that is full of symbolism. It represents a way through and as a doorway, suggests a before and an after. The doors in *Thira* are all the more significant because they deliberately imitate false doorways – like in certain spiritual buildings. In an Egyptian *mastaba* they 'open' the way into the kingdom of the dead for the deceased. In the Medici chapel in Florence Michaelangelo sculpted blind windows from stone with the same meaning. So the work is like a transitory place for the spirit – at once both reassured by the stability of the geometry and encouraged to pass beyond its limits.

18 *Chapter*

Robert Ryman (born 1930)
1981
Oil on linen canvas, 4 metal clasps
223 x 213 cm
Pompidou Centre, National Museum of Modern Art, Paris, France

It's not a painting

It really is a painting; the canvas is covered with paint but not in any ordinary way. 'Painting' doesn't always mean 'picture of something'. Sometimes it's just an object like this one with almost nothing on it.

But there's nothing there!

There aren't any people or characters that you can recognize. But the paint is certainly there – and it didn't get there all on its own. So we know something must have happened; you can imagine the painter making his brushstrokes . . . And now air crosses its surface, the light changes . . . It's like listening to someone whispering; you have to listen closely . . .

It's like snowflakes

At first you think the painting is the same all over, and then you see that the surface is flecked as though it's covered in snowflakes. It's very light, very peaceful, it's hardly there, but the effect totally changes the canvas.

It's boring

That depends on what you're expecting. It might be disappointing that there isn't a story to see. But if you change your point of view you can imagine that it's a portrait in a single colour. Instead of depicting a face, it describes the white on a canvas.

◊◊◊

Maybe it isn't finished

It is. But in any case, only the painter themselves can decide when a painting is finished, even if their decision is surprising for us. As soon as you accept that, things get a bit easier and you just have to trust the artist.

He could have just left the canvas blank

He could have done, but for him that wouldn't have had any meaning. He was interested in seeing the beginning of something. He wants to bring the viewer in front of a canvas that is in the process of becoming a painting. It's very difficult to pinpoint the moment when a painting starts to be a painting, just like when you watch the dawn and try to pinpoint the moment of the sunrise. All of a sudden the sky is full of light, often without you having realized.

It's not exactly difficult to do

Technically no. All sorts of people – and not just painters – could create something similar without much effort. But on the other hand it's difficult to see things like Robert Ryman did; to have such a fine sensibility, to pay attention as he did to the tiny movements which most people ignore. And what's even harder is to have the courage to face misunderstanding and mockery head on by creating a work like this.

You don't usually see the clasps on the wall

Like a lot of twentieth-century paintings this one isn't framed. So it's free, uncaged, it has no limits but itself. But it's certainly true that Ryman liked to leave the metal clasps which attached his paintings to the wall visible. It means that the painting doesn't risk being mistaken for a mere decoration – above all it's an item of meditation. The artist sometimes had the clasps specially made and, in line with his wishes, they are always mentioned with the other characteristics of the painting; the title, the materials and the dimensions.

Is it significant that it's a square?

Yes it is, because being square the painting denies us the usual reading direction (left to right, right to left, top to bottom or bottom to top, and with a square even the diagonals are equal). He soothes the eyes, slows them down and ends up doing away with any 'direction' at all. Looking at this painting encourages you to stay still, to rest. It says that there's no point in looking for anything else; you've arrived.

◊◊◊

What does the title *Chapter* mean?

It seems that titles don't hold a lot of meaning for Robert Ryman, he uses them to distinguish one painting from another rather than as a means of explanation. They are more names than titles – which again indicates Ryman's rejection of painting as representation. The word 'chapter' here suggests a certain clearly limited space – like in a book. One contains text, the other paint.

Did any other artists do white paintings?

Yes, this is by no means unique. White is above all a sign of absolute light. It evokes the white page before the writer or the canvas ready to be painted but it also makes you think of a colour wash covering everything up. On an abstract level white can suggest both birth and death – it's a rich field of reflection for artists. Reducing their means of expression to the absolute minimum allows them to tackle the deepest of subjects. Other examples include the works of Robert Rauschenberg (who did several *White Paintings*) or Piero Manzoni (*Achromes*). The first and most famous white painting was painted by Kazimir Malevitch in 1918 called *White square on a white background*.

Well, whoever painted it, it's still just white . . .

It's never the same thing. Everything matters; the format, the treatment of the materials and of course the context of the work. The Suprematist painting by Malevitch close to the Russian revolution in 1917 evoked an ideal – a translucent square comes imperceptibly away from the background, tears itself from the cosmos that gives it life and for the first time, shape. It's the world and its creation. Ryman on the other hand was working in a world where objects – essential in a consumer society – had a great role in artistic inspiration. He uses white to avoid having to cover the canvas with one or several other colours which would negate the concept of the blank canvas. For him the white of the pre-painting can only be thought of as a mere support. The white paint serves to confirm the white of the canvas. So the object-painting wins over the representation-painting. From one painting to another the quality of the white differs as much as the quality of silence differs from one place to another.

Why did Robert Ryman paint several paintings the same?

They aren't exactly the same as they aren't mechanical reproductions. The artist isolates a little corner of what he sees in the world, a bit like as scientists isolate molecules in an experiment. And, thanks to him, for a moment we see nothing but the presence of an object named a 'painting'. And the inspiration is infinite; if you think you always see the same thing in different works then you are muddling up the different artists' distinct voices. If white is the sound of Ryman's voice then each painting is just a part of what he has to say. Each painting is a moment of the artist's thought, a note in his breathing.

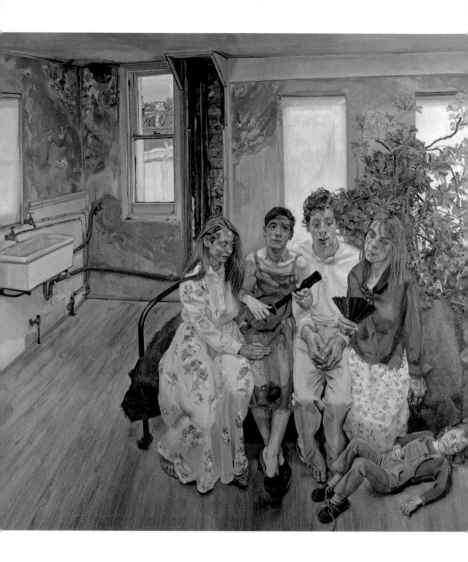

19 *Large Interior W11 (after Watteau)*

Lucian Freud (1922–2011)
1981–3
Oil on canvas
186 x 198 cm
Private Collection

Who are they?
They are the artist's children and the children of a friend of his. The youngest one is lying on the floor as children that age like to do. There wasn't much room on the bed and it makes the painting more interesting.

They're playing music
The girl with the yellow and pink dress is playing the mandolin, she is focusing on the tune and looking into the middle-distance. The others have their eyes lowered – they are concentrating on listening to the music. The little girl on the ground is watching us. She's the most curious, she isn't doing the same things as the others.

Her shoelaces are undone
It doesn't matter. She's not about to go out so she's unlikely to fall over. Two of the older children are barefoot. The artist didn't make them look smart. He preferred them as they were, natural and a bit shambolic.

They've left the tap on
Someone can't have turned it off properly. Or it's a bit loose. The artist is completely absorbed in his work, so small practical details like turning the tap off get overlooked. Too bad if the plumbing isn't working. He's not worried about the state of the walls either. His work is far more important than pretty décor.

◊◊◊

Are they in the kitchen?
You might think so because of the tap and the sink, but actually they are in an artist's studio. It was originally designed as an apartment and the sink is in the position it would have been in had there been a kitchen. But now it's used to clean paintbrushes as you can see from the grey-stained porcelain on the inside of the sink. It may seem like a mundane object but Freud was so interested by the detail and nuances that he chose this sink as the main subject in one of his other paintings.

Their clothes look all crumpled
No more than the children themselves do. The people in Lucian Freud's paintings always look a bit 'crumpled' as if the painting has mixed everything up on the

inside. There are no smooth surfaces; the world is never smooth in his paintings. It suggests that all sorts of things are happening on the inside – or have happened and left their mark behind. There are marks which are easy to explain, like the damp patches on the walls, and there are others which are harder to put your finger on, but which remind you of a piece of clothing that has already been worn. Even if they are quite clean, they don't look 'new' any more. And that's exactly what Lucian Freud is showing; a 'used' world. He makes us understand that in painting people or things he is capturing a little of their past.

Why are they all bunched up together?

The painter sat all four of them next to one another on this iron bed (which appears in other paintings of his) so they didn't have much space. But putting them like that also makes it clear that they are a unit – a musical group in the most obvious sense. Their shoulders and arms overlap one another. Even though they are sitting in a very ordinary way, they are linked like the notes of a tune. The two girls on the right and the left are slightly turned towards the centre and the others are as interlinked as the sticks of a fan. The little girl at their feet creates a contrast – or a counterpoint – to the general tonality.

You can hardly see the outside

Three of the four windows are obscured by translucent blinds. Painters regularly face problems with lighting. It's such an integral part of any composition that they have to arrange the lighting to suit the painting. The fabric screens soften the light without blocking it out. What's more, the only outside element we can see – a building with a slate roof and a view in the distance – is to one side of the canvas, so as not to distract the viewer's attention. So whilst the scene isn't cut off from the real world it appears all the more intimate.

The floor looks a bit sloped

The artist's perspective is slightly elevated, making the floor appear to fall away and the effect is accentuated by floorboards being painted with broad strokes of paint. It makes the whole thing feel somewhat unbalanced – like van Gogh's bedroom in Arles where the painter used the same technique. The figures look all the more attentive as though they are having to make an effort not to slip – but maybe it's nothing more than their focus on holding the right note.

◊◊◊

What does 'after Watteau' mean?

It means that Lucian Freud was inspired by a painting by Antoine Watteau, a French artist from the eighteenth century. It's not a copy but a homage to a painting that he admired. In *Pierrot Content* Watteau shows the characters of the Italian Commedia dell'arte, Pierrot, Columbine and Harlequin, together in a park which may be real or a stage backdrop. Broadly speaking Freud's people are in similar poses, although the mandolin, the fan and the colours of the clothes are more alluded to here than being faithful reproductions. The green plant refers to the virgin forest and plays the role of the little wood in Watteau's painting, but here, a few yellow leaves remind us of the passage of time.

Is it common to paint 'after' another painting?

Artists have always studied their predecessors but in the twentieth century the transposition of a painting to a greater or lesser degree was very popular. Picasso no doubt did it most – painting works inspired by Poussin, Velasquez, Delacroix and Manet. Lucian Freud was also inspired by a painting by Chardin, *The Little Schoolmistress,* where he saw 'the most beautiful ear' ever painted and which he reprised much more faithfully. It's a sort of visual commentary which becomes a work in its own right. By painting 'after' Watteau or Chardin Freud is looking to artists with styles totally different to his own and which teach him a new way of seeing the world. Through his paintings he enters into a dialogue with them.

This painter has got the same name as the founder of psychoanalysis

Yes. Lucian Freud is the grandson of Sigmund Freud (1856–1939). His father was the youngest son of the great doctor. Born in Berlin, the artist fled Nazi Germany to England with his family in 1934. It was only in 1938 – one year before his death – that his grandfather resigned himself to leaving Vienna and joining them in London.

Did Freud do a lot of portraits?

Yes. One of the most famous was of Queen Elizabeth II who agreed to the artist's request that she sit for him wearing a crown. He gave her the painting to celebrate her 50th jubilee (marking fifty years on the throne) in 2001. You see her face side-on, compressed by the four sides of a tiny canvas (23.5 x 15.2 cm). Surprising in its simplicity it's a painting all about the constraints of power.

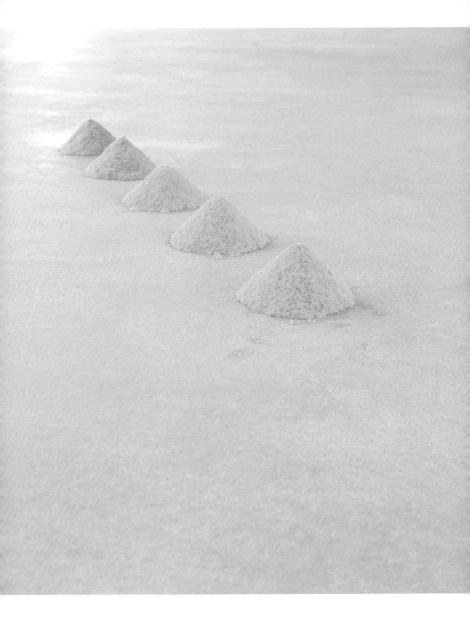

20 *Five Mountains not to climb on*

Wolfgang Laïb (born 1950)
1984
Hazel pollen
Height 7 cm

It's like a desert

These little mountains of pollen are neatly lined up on the ground. Everything around them is empty so in that sense it really could be a desert landscape. It's a very small piece but it's capable of conveying the idea of a huge space.

All the mountains are exactly the same

They are made of the same material and they're the same size but there are subtle differences: the summits vary in their pointiness and the one in the middle looks less solid than the others; it might have gradually started to crumble. And the bases aren't all as neat as one another. Little by little you can start to tell them apart.

They are a lovely colour

The colour evokes sunlight; you can imagine a landscape somewhere hot. The white ground really heightens the colour and if they were placed somewhere else the harmony would be quite different.

You can see marks on the ground

The mountains aren't perfect – they were made by hand not by machines. Some specks have fallen or been blown there by the wind while they were being put in place and the artist wants those to remain visible. In fact a little blow or a sneeze is all it would take to destroy this work.

They're only mountains for ants

That's true and if you take the point of view of an ant it's easy to see them as mountains. The artist makes us change our way of looking at things. When you think about it, as far as the universe is concerned we really are smaller than ants.

◊◊◊

Is it a painting or a photo?

What you see here is only a photo of the work which is actually five real mountains of pollen. The photo allows you to fix it in your memory which is all the more important with this kind of work that can easliy disappear. Some artist's work is comprised of an ephemeral piece together with a photo of it and sometimes texts, essays or descriptions. But this photo isn't part of Laïb's work.

Why did the artist use pollen?

Laïb works with the seasons and with materials available. Hazel trees produce pollen in May whereas from spring to autumn dandelions provide the pollen for bees to make honey. According to legend the bright dandelion is made from the dust thrown up by the sun's chariot. The hazel tree also has its own story. As its wood is so supple it was believed that the hazel could not be broken by lightning and it was said to ward off snakes or evil spirits. And when people went looking for water or even for gold they would hold a hazel switch that would start to vibrate when they were near to what they sought. Using this pollen, Wolfgang Laïb evokes part of that legend.

Is it significant that there are five mountains?

Yes, because the number five can signify the five senses – sight, hearing, touch, taste and smell – and so the relationship that humans have with the world around them. It can also suggest the five extremities of the human body – the four limbs and the head. A cross shows four directions but the point at which its lines cross creates a fifth, the centre. So five is a symbol of balance and harmony. It's also significant that the mountains are 7 cm tall because seven is the sum of three (the sky) and four (the earth) and is the sacred number in most cultures. It evokes creation and the totality of the universe; seven days in a week, seven colours in a rainbow, seven notes in a scale . . . So these mountains represent the deep connection between man and nature. They sum up the world.

Why does he say that they're not for climbing on?

Normally 'not for' means that the act is forbidden or beyond our capabilities. Here it's the opposite – it's *beneath* our capabilities. The mountains are so small that they make anything we are used to doing useless. You feel helpless, as clumsy as a fully-equipped climber setting out to scale a mole-hill. It means you have to change your attitude, abandon your grand schemes and stop trying to master things, trying to dominate who or whatever it is. You have to calm yourself and take the time to look, to be present. That's all.

◊◊◊

Does Laïb always work with natural materials?

Yes. He particularly likes to work with very fragile natural materials like bees-wax, milk, rice and of course, pollen, which takes months to collect. They are nourishing substances which he uses like an offering. Sometimes he combines them with durable materials like the highly polished marble in his *Milkstones*. As his works are only ever temporary he collects up the elements and uses them again in other works – so they don't die but metamorphose. Nevertheless, Wolfgang Laïb's works aren't designed to be shown out of doors. They come from nature but when placed inside a gallery they create a meditative space of simple purity.

Why are his works so small?

He wants to create an antidote for the modern world that is obsessed with all things huge and the constant search for the spectacular. Laïb favours analysis, silence and slowness. For him every grain of pollen and every drop of milk is precious. His small format works encourage reverence – scattered thoughts and disparate feelings are drawn perfectly together, just like the piles of pollen creating the mountains. Though he does not follow a particular religion, the artist learnt a lot in India where he was a frequent visitor from a young age. His work is ascetic – the only reality is the interior. Though they may be small his mountains reach for the sky, like a soaring spirit, and that is their true grandeur. And that's the true reason why it's impossible to scale them – the altitude of thought is infinite.

The artist has done almost nothing

On the contrary! Wolfgang Laïb doesn't transform his materials as a sculptor or a painter does. But he harvests, he collects, pours, sifts and sprinkles . . . His work is very gentle, working to the eternal rhythm of the seasons. In that respect he belongs to the Far Eastern tradition where a painter or potter might wait months or years for a work to come to fruition with a perfect stroke. Here Laïb has created cones of pollen – in other works it's squares – and they all look as though they have been made out of pure light. The geometric shape brings perfect order to the material. It's a meditative ritual to create them – not a production process. And he doesn't care that his five mountains could be destroyed in a second, because that is the very nature of things and the work is the visible sign of life – here and now.

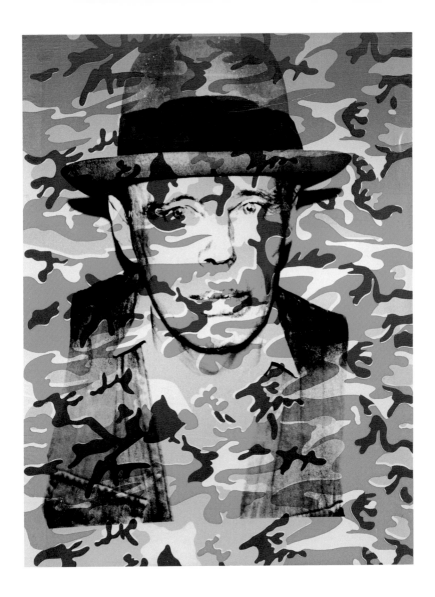

21 *Camouflage, Joseph Beuys*

Andy Warhol (1928–87)
1986
Acrylic and screen printing ink on canvas
283 x 211 cm
Gallerie Berndt Klüser, Munich, Germany

There's a man there in the background

We are used to looking at portraits without asking their permission. This time it's the subject who is looking at us – half hidden behind green, brown and white shapes, as though he was hiding behind some leaves . . .

Has he been beaten up?

No he hasn't, but his face does look as though it's injured, the coloured areas sliding across the surface of the painting coincide with his eye (black and brown) and his nose (yellow and green). In this way the artist has managed to suggest that the subject is full of – and covered in – suffering.

His body is cut off

That's because the portrait was created in two stages. The artist didn't want us to ignore the fact that it's based on a photo, so you can see the edge of the original picture towards the bottom of the canvas.

He's wearing a hat

Joseph Beuys liked to feel protected by wearing a hat, so like a uniform he always wore it, along with a fisherman's jacket with lots of pockets. People knew he was always the same . . . like a character you can trust who always wears the same costume.

◊◊◊

Who is it?

It's Joseph Beuys (1921–86), the most famous German artist of his generation. He started working after the Second World War – originally as a sculptor and then by putting himself centre stage in what he called 'actions'. He was also a great teacher.

There's nothing to show that he's an artist

That's true. This painting doesn't make any reference to Beuys's work – no artist's tools, or works or any particular scenery to suggest that he was an artist. Warhol shows that what counts above anything else is his existence, his presence and his thoughts. And for Beuys what was most important was that the whole human being was engaged.

Usually the background is *behind* the person

If Warhol had used the camouflage as a simple background, that would have suggested some context or a state of mind. But he wanted us to understand that we aren't seeing all there is to this man, nor of himself either. In Warhol's view we too are 'camouflaged'. For him it was as if there was constantly an opaque screen between us and the exterior world – so we only ever have access to a small part of what is really there. It's a game of hide and seek with reality.

It reminds me of a passport photo

That's because of the very simple pose and the subject looking straight ahead. It's a bit like a 'Wanted' poster. In fact Warhol used that exact format a few years earlier. In one sense Beuys is indeed 'wanted'. As an artist he is essential. We need to know where he is and what he is doing, because we value his contribution to society. Though the photo is very mundane, at the same time it signals that the individual is quite unique.

But it's easy to do a portrait if you just use a photo!

Technically speaking, yes it is easier than doing a traditional painting. But above all this is a new way of thinking about art. Warhol believed that the modern world no longer needed to produce portraits in the way it had done in the past. So he used very ordinary photos, the kind you find all over the place. The more ordinary the better as far as he was concerned, because pictures like that were a much more accurate reflection of real life than any magnificent painting. And the most important thing was that by painting a photograph he was creating not just a portrait of the subject but a portrait of the photo as well, a portrait of the image of the person . . .

◊◊◊

So did Warhol take the picture of Beuys himself?

Yes, Andy Warhol photographed his models with a Polaroid camera – a kind of camera invented in 1947 that produced a print within a few seconds. Sometimes he would take hundreds of photos to choose from. It's the fascinating speed as well as the intended simplicity of the pose that give the illusion that this is a somewhat superficial piece. But in fact Warhol was capturing an instant truth about the model – Beuys in front of the lens looks like he is being hunted, caught for a moment, like an animal in the headlights of a car. For this portrait the artist used a photo he had taken seven years earlier when he first met Beuys in Dusseldorf.

So is it photography or painting?

It's both at the same time because the photo and the painting represent different stages of producing this portrait. The final work is a silk-screen print. Silk screen printing is a Chinese technique introduced to America at the end of the nineteenth century. The procedure can be compared to a sophisticated system of stencils. The process had been modernized and was very popular during Warhol's heyday and Warhol adapted it for his own needs. His first step was to retouch the original photo, reworking the details of the face to get a stylized version. Then the next stage was to organize the colours. Printing allowed him to make many copies of the same composition. So it wasn't a simple, mechanical reproduction of something visible but a series of successive transformations from reality, each based on a series of choices by the artist.

Warhol's really colourful paintings are the ones that are best known

Yes. He often used very vivid – sometimes almost fluorescent – colours, the kinds of colours you see in adverts, on packages at the supermarket or on the signposts in twentieth-century towns. Warhol acknowledged this popular visual reality and indeed built his whole career on it. And that's where the term 'Pop Art' came from. His images give the same currency to a Coca-Cola bottle, a tin of Campbell soup or a face. By bathing their faces in colours with no connection to reality he would turn the faces of his frequently famous models (political figures, business men, film stars) into simple, elegant and decorative objects, whose human dimension it is easy to forget.

Why camouflage Joseph Beuys?

Above all camouflage evokes war; the Second World War of 1939–45 which was the starting point for Beuys's work, or the Vietnam War of 1961–73. But during the 1980s camouflage had also been adopted by the fashion world and still today camouflage trousers or t-shirts are very popular. So the portrait suggests the mixture of horror and futility peculiar to the twentieth century. The same contradiction existed between Beuys and Warhol: the one a German, a believer in the redemptive power of art and the other an American fascinated by the world of the 'people'. Though they may have seemed polar opposites these two artists had great respect for one another and were actually two sides of a single coin – each defining in his own way the search for what lies behind appearances. So Warhol here is paying his respects to Beuys who had recently died – all the deeper for the fact that he used camouflage in several self-portraits later that year.

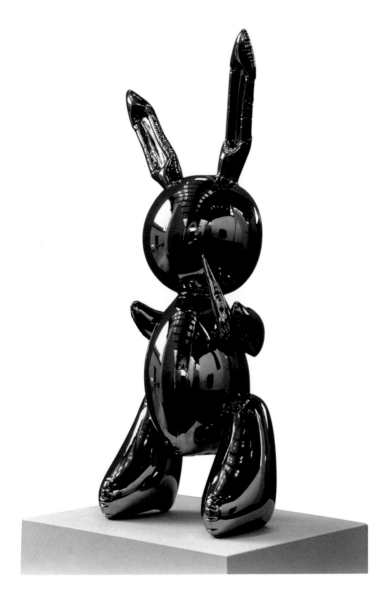

22 *Rabbit*

Jeff Koons (born 1955)
1986
Stainless Steel
104 x 48 x 31 cm
Sonnabend Gallery, New York, USA

It's a rabbit with a carrot

Even from a distance you can recognize his ears. There are no eyes or muzzle but with its carrot it looks like the rabbits in fairytales or cartoons . . . It doesn't actually happen like that in reality very often, but you can hardly imagine a rabbit without its carrot any more than you'd picture a dog without its bone.

It looks like a cuddly toy

It's more a kind of a statue of all the toys in the world. Adults who see this in a museum may be surprised to find themselves remembering their own cuddly toys, or their children's or grandchildren's. We thought we'd forgotten them long ago and then here comes this rabbit re-awakening all those memories.

It's all round

Yes, the artist has imitated a balloon animal. It looks soft and light, particularly its ears and paws, as though it was a toy full of air. But you can't trust it too much – it's made of steel. Beneath the soft appearance this rabbit is actually very tough.

What's it called?

It's called *Rabbit*. It doesn't have a special name – or a history either. So everyone can imagine it wherever and however they want.

◊◊◊

You can see yourself reflected in it

You can see yourself on it because it reflects what's close by. But seeing yourself 'in' it is a pretty idea. A mirror reflects things, people, the colour of the walls or the floor and the light. Instead of having a fixed colour the rabbit changes, like people change their clothes. It has people on his head and on its tummy too . . . you can see what it is thinking, what it hears, what it swallows; this rabbit is full of ideas and delights.

Where did the idea for this rabbit come from?

The artist was inspired by the cheap figurines of Easter bunnies. People put bunnies in their houses or on their lawns in a tradition brought over by German immigrants in the eighteenth century. The rabbit, which breeds very quickly and has lots of babies at a time, is an ancient symbol of fertility and so of life. Which

is why it ended up being associated with Easter, the Christian festival of the resurrection. In many countries they eat chocolate eggs and rabbits. According to the story it's a real bunny who hides the eggs – another symbol of life – in gardens on Easter morning.

This one is easy to understand

Making it easy is one of Jeff Koons's key aims. In front of *Rabbit* no one can feel ignorant – as you often can in museums. Like all sorts of commercial products it's an object made of simple shapes and an everyday material. That said, the interest of a work doesn't lie solely in its appearance but also in the reasons that made the artist create it.

Balloons aren't serious

Exactly. A balloon doesn't last that long. Sometimes they burst, sometimes they deflate very slowly and end up all shrivelled. The artist, who sees well-inflated objects as a sign of optimism and energy finds that very sad. So he transposes them into steel so they are no longer at risk. After all, don't we sometimes say that we feel 'pumped-up' or 'deflated'? Koons gives his rabbit a 'steel will'. Art can be a means of turning humour on its head.

Steel isn't a rare material

Rabbit doesn't forget that it is a transformed toy. It only *looks* like the kind of metalwork that has impressed people – visitors to churches or chateaus – with its sumptuousness for centuries. Shiny metalwork symbolized divine light, so in the past, kings and religious dignitaries would commission works from artists to display their wealth or power, or even the purity of their souls. *Rabbit* mocks all those ideas – its world is more the world of sports cars and it doesn't have to be made of gold or silver to dazzle like bodywork in the sun.

◊◊◊

Do people often make statues of animals?

Yes, history is full of them. You only have to think of the statues of Egyptian animal deities – like the cat goddess Bastet or the she-wolf Rome feeding her twin offspring Remus and Romulus. Since ancient times there have been sculptures of people riding horses (the oldest surviving one is of emperor Marcus Aurelius). Later it became popular to reproduce exotic animals, like lions and bears, in bronze or marble. But it was always figures linked to religion or history or at

the very least wild animals admired for their nobility and strength. But *Rabbit* is just a boring old rabbit – which does at least make it rather a novelty – and it's not even a model of a real rabbit. So this is a unique figure, it contrasts with the bronze hares by British sculptor Barry Flanagan (1941–2009), who are as malicious, agile and even sad as *Rabbit* is passive and content.

So is it for children?

No there is no such thing as children's art. Of course, you might think of children's book illustrators which have been with us since the nineteenth century or of special films, but these are from quite a different discipline – one which targets only a certain section of the public either for commercial or educational reasons. The point of *true* art, on the other hand, is to touch everybody and anybody – even if it's on very different levels. Koon's work may seem childish but in truth there is nothing innocent about it. It is a very dispassionate response to the art of the past. What is more, Koons himself does not get involved beyond the original idea. His pieces are digitally designed on computers with help from numerous assistants. Rather than leading the viewer towards intellectual or spiritual ideas – as art used to do – *Rabbit* gives the viewer an immediate vision of the world in which they are actually living: a world where fairytale characters become industrial objects.

Does *Rabbit* have a symbolic meaning?

In the ancient world it was believed that rabbits were hermaphrodites (that is to say both male and female) and they reproduced so quickly because they didn't need contact with one another. Hence the idea of the rabbit being associated with chastity and it was often depicted in images of the Madonna and Child. But just like a glove, a symbol's meaning can be turned inside out depending on the context. For Jeff Koons there is no desire to moralize, rather the rabbit alludes to unbridled sexual activity. But then again, if the artist is to be believed, his work has no deep meaning at all. Perhaps we should understand *Rabbit* as a figure which in the past was rich with symbolism, but is now emptied of its meaning and transformed into an icon of superficiality.

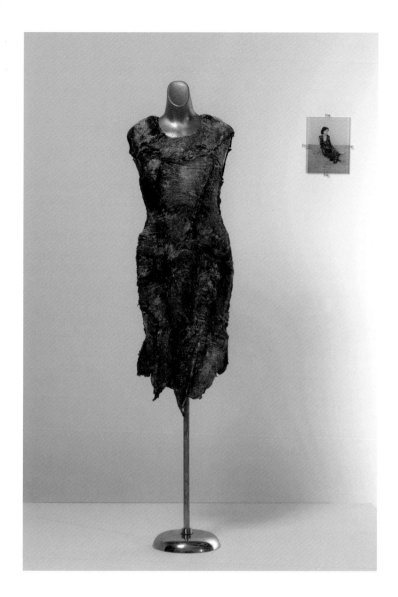

23 *Vanitas: Flesh dress for an Albino Anorexic*

Jana Sterbak (born 1955)
1987
mannequin, flank steak, salt, thread, color photograph on paper
113 cm
Pomidou Centre, National Museum of Modern Art, Paris, France

It's like in a shop

This dress isn't for sale, but because it is displayed on a mannequin like in a shop or a shop window we can tell it doesn't belong to anyone in particular. If it was being worn by someone, or even lying on a chair it would be quite a different matter. You'd be tempted to imagine the history of the dress but in this case, it's the dress that's the important character.

It's an old dress

It looks tattered and frayed around the edges, so you might think that it has been worn a lot. But this dress is actually new – its problem is that it ages very quickly. It is curling up and drying out.

It isn't pretty colours

The artist wasn't trying to make something beautiful. She wanted us to be able to observe the passage of time and the way it changes things. At one point the dress was red, then it became pink and finally greyish. Like a real person it is not all that it might seem.

There's a photo behind it

It's a little picture of the artist, Jana Sterbak, in a rather dreamy pose wearing this very dress. She is the only person ever to have worn it, but she wants to show that it *is* wearable. The photo is the proof.

◊◊◊

What's it made of?

It's made entirely of beef. The lighter marks you can make out on the surface are either the fat – just like in a real steak – or coarse salt which can be used to preserve meat. The salt helps to stop the dress from rotting by absorbing moisture.

Is it possible to make a dress out of meat?

The artist has chosen a material that suits her. As long as she was dealing with non-traditional materials, it could have been anything. In this case pieces of salted meat have been sewn together with a thread to create a regular shape, just like a length of fabric. Then, using a pattern, pieces are cut out and sewn up on the metal mannequin to create a bodice and a skirt. The fattiest pieces

are arranged on the inside so that the dress is as uniform a colour as possible. Of course, this method doesn't allow for fine detailing but the result has a timeless quality. It's the idea of a dress – an absolute dress.

No one would want to wear a dress like that!

It's not made to be worn. The photo shows that it is technically possible to wear it, but this dress was made for quite another reason: it's playing a 'role' like an actor on a stage. It 'speaks' about what it's like to be a dress, what it means to cover a body, to touch skin and to become like a 'second skin'. And then to be turned inside out. If it had been made out of fabric this would have been no more than a piece of clothing. But the artist didn't want to compromise. She needed real meat to make this dress.

It looks like a cross-section

Cross-sections are used for studying anatomy as they present everything that lies under the skin – muscles, tendons and so on. In a much less scientific way and without providing any information about the body, this dress also reveals what is normally at least partially hidden. It directly represents an expression used to describe someone who is highly sensitive, a 'tortured soul'.

◊◊◊

You don't notice it's meat straight away

No, particularly if you aren't expecting it. You walk calmly up to a simple, unspectacular dress and then you realize you are standing in front of something inconceivable. You might not notice it from a distance but up close it's a brutal discovery. It makes us realize how important it is to look at things properly – the amount of attention we give them decides whether they exist for us or not. Once you are over the initial shock – or even disgust – you gradually realize that the animal's flesh is all the more disturbing because it is taking a woman's form, so the dress seems to be made of human flesh. And of course, human flesh is itself nothing but meat. From a distance the dress could evoke pleasure and elegance. From up close it evokes reality and death.

The title is complicated

The title explains the thought that underpins the work and that justifies its strangeness. *Vanitas* is a Latin word meaning 'vanity' that is frequently used in art. It's biblical in origin and denotes the emptiness of human existence when compared to eternity. In general the Vanities appear in still lifes full of motifs that

suggest the brevity of life, like skulls, half-burned candles, flowers and so on. Jana Sterbak's work picks up on this theme. In the past, a picture would capture a moment in time but here it is the work itself which submits to ageing and decrepitude. The second part of the title speaks of accumulated suffering. This dress of red, edible flesh is for a woman who is both albino and anorexic; that is to say someone who's skin and hair are almost white and someone who eats very little. So the work addresses the one person who might have a real need of it, but also the only one who can neither receive or accept it. It transmits an image of humanity that is at once both tragic and absurd.

How can you preserve a piece like this?

You can't really preserve it, because, even though it's salted, meat can't remain in a museum indefinitely. The artist has developed processes to follow to make a new dress every time that this piece is needed in a museum. The details of the cut, the assembly and the sewing demand the presence of a stylist and are as specific as for a normal item of clothing. The way that the dress is displayed, using a metal mannequin, is also pre-determined. So in a way, this means there are two elements to the piece – the dress itself and the text that explains how it is made. Of course, even given these conditions it would be impossible to create an identical dress each time – each one is unique and constitutes a new phase in the life of the work, which is never finished.

Are there lots of pieces of art made from perishable materials?

Yes, there were quite a lot made in the second half of the twentieth century. Using perishable foodstuffs offers a whole new take on daily reality and a reflection on consumer society. The work itself is presented like a consumer product, but at the same time the fact that it is rotting means it can't truly be owned. It serves to underline how the world of thought is much more powerful than the material world. Another example is *Untitled (Eating Structure)* created by Giovanni Anselmo in 1968 and currently displayed in the French National Museum of Modern Art in Paris's Pompidou Centre. It brings together a block of granite with a lettuce. The work demands that the gallery where it is displayed takes constant care of it, the lettuce must be maintained or replaced – like the meat that makes up this dress. So art dictates its own laws.

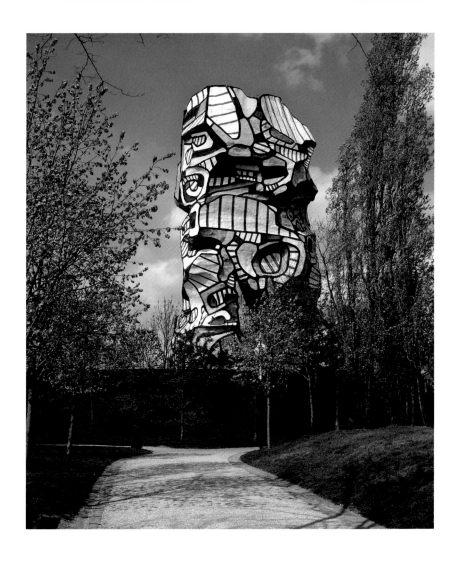

24 *La Tour aux figures*

Jean Dubuffet (1901–88)
1983–8
Polyurethane paint and epoxy resin
24 m
Centre National des arts plastiques – Culture & Communication Ministry, Paris
Departmental Park on Ile St Germain, Issy-les-Moulineaux, France

This tower is all battered

It's a bit askew like the trees and rocks around it. The artist made it like that deliberately so that it would be at home in natural surroundings. Despite its size, it's as crooked as an old boulder.

There are people on it

On it, inside it, around it! The tower is made of many people piled up and living with one another. As they stick together they form a funny kind of tower. If they were to be separated the tower would collapse.

I can see teeth and eyes

The vertical lines towards the top suggest teeth and the little circles look like eyes . . . The hard part is to distinguish the characters one from another. It's a kind of beautiful chaos – everyone is chatting and moving around inside.

There aren't many colours

Apart from the white background there is only black, blue and red – the ballpoint pen colours that everyone knows. One day the artist was doodling while he was on the phone. He had the idea of using the same shapes and the same colours to create and paint a work on a grand scale.

◊◊◊

It looks like papier-mâché

Yes. Working on a grand scale Dubuffet has done just what children who have no idea of how to sculpt or imitate a model would do. The shapes you get from mixing papier-mâché interest him exactly because they don't look like anything in particular. For him it's very important that his work should retain its freedom. But of course for a work that's 24 meters high he had to use very strong durable industrial materials. The skeleton is made of reinforced concrete and he used epoxy resin (used to make surfboards) to model the various sections, which were originally made of polystyrene. Then he used polyurethane paint to decorate them.

Do people live in it?

It wasn't designed for people to live in, but you can certainly go inside. There are twisty staircases leading to different floors and a large room at the top. Inside the same black lines on a white background create tangled shapes on the walls. The artist named this internal apparatus the 'gastrovolve' as though the tower had a stomach as complicated as a labyrinth. He thinks of the tower as a kind of living creature and when you go inside you leave the real world behind because there aren't any windows. On the inside there is no communication at all with the outside.

It looks like a totem pole

Perhaps that's because the tower appears unexpectedly all alone among the trees. Its size means it dominates the surroundings and it looks so odd that it changes our perception of nature. Even though you may be in a park close to Paris, it's easy to imagine yourself far from the 'civilized' world as if the tower had magical powers. It seems to belong to a different world from the one where we live – a bit like an alien visiting our planet. For Dubuffet art was the real magic as it has the power to pull the viewer out of their everyday life and into their imagination.

Why is it there?

The artist chose the location at the point when it was commissioned, in 1983. But he had waited a long time, as he was eighty-two and this was his first public commission. It took several years for the work to be completed. The maquette was produced in 1967 and construction started in 1985, but, as it took three years to complete, sadly Dubuffet died before it was finished.

◊◊◊

The word 'Hourloupe' often comes up when people are talking about Jean Dubuffet

It's a word that Dubuffet invented to refer to a group of his works – the Hourloupe Cycle – completed between 1962 and 1974. The word is an amalgam of a number of French words whose sounds and meanings Dubuffet played with: *hurler* (to scream), *hululer* (to hoot), *loup* (wolf), *Le Horla* (a short story by Guy de Maupassant about an invisible being) or even *entourloup* (a mean trick). There are no doubt other words in a similar register. What matters here is Dubuffet's unprecedented neologism to describe the spirit of the paintings and sculptures in question. Like La Tour they are based on the play of black lines and white, blue and red areas. The word defies categorization, just like Dubuffet's

art which is stark in its originality when juxtaposed with nature; an imaginary landscape one of whose inhabitants is immediately identifiable – a work by Jean Dubuffet.

Is this Outsider art?

No, Dubuffet's work is not *Art Brut*. But it was he who coined the term in 1945 to describe a certain type of art – paintings, drawings or objects produced by individuals with no artistic training, particularly the art of the mentally ill. These people had no concept that their art might be looked at, or even sold, but their uninhibited self-expression held a great aesthetic richness. What is more, and this is key, at the end of the war art was rediscovering its vitality, independent of fashion and theory. Jean Dubuffet was one of the first to appreciate and collect Outsider art and he donated his collection to the city of Lausanne in Switzerland. For him Outsider art was an inspiration because it was so formally independent, it showed completely untrammelled creativity and above all complete authenticity from a human perspective. As a cultured man, familiar with the artists of his time, he was fascinated by this alternative to traditional art history.

It's a mixture of sculpture and painting

Yes, painting and sculpture are given equal importance in the Hourloupe. In some ways they both come from writing. It looks as though the artist had taken his doodles and somehow enlarged the paper, scrunching and moulding it to give it shape. And it continued to grow until it was the size of a building. There is no distinction between these different stages, just a question of scale – you start with a pen stroke and end up with a tower. So the tower appears like a three-dimensional scribble – it tells a story in an unknown language with words that don't exist. The discovery of shapes leads the viewer into a kind of labyrinth, which is a very logical progression if you recall that Jean Dubuffet originally wanted to be a writer. He often gave his art very poetic, funny or surprising titles as though they were books. And he certainly built them like eternal sentences.

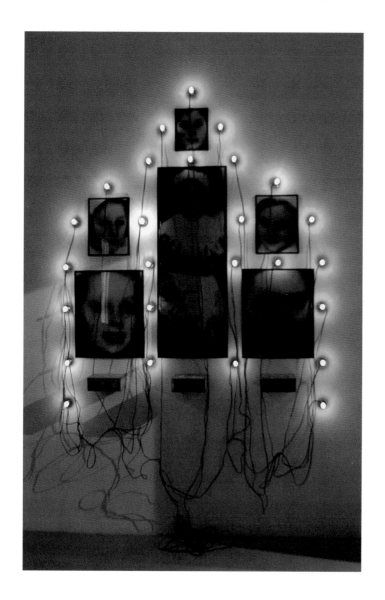

25 *Odessa Monument*

Christian Boltanski (born 1944)
1989–2003
6 black and white photographs, 3 small biscuit tins, light bulbs and electric wires
203 x 183 cm; central photograph 130 x 50 cm
The Jewish Museum, New York, USA

It's photos hung on the wall

They are photos of children, close-ups on the faces looking out at us. There are four different sized photographs: one tall one in the centre, two large ones on either side of that and above each of those a smaller one. Plus there is a single, small-sized one at the top. They are displayed like family photos.

There are lights all around the pictures

The light bulbs are part of the work. Placed at regular intervals above and beside the pictures they cast small circles of light on to the wall. The wires also play a role – of course they allow the light bulbs to be plugged in but they also suggest the idea of small, fine flower stems.

It's hard to see the faces

Even though the light bulbs are switched on the faces seem dark. There are some truths which are hard to see or comprehend, no matter how hard you might try. Sometimes you have to wait until your eyes get used to the dark, so you need time and patience. Sometimes even that isn't enough, but at least then you get used to not being able to see very much.

Who are the children?

The work doesn't tell us. We don't know anything about them – not even their names – but that's not important. The important thing is that they existed. No matter how many details we may or may not know about them, nothing will change the fact that they existed. They were once as real as we are standing looking at them.

◊◊◊

They are laid out symmetrically

Yes, the whole work is laid out in a very balanced, almost architectural style around a sort of central pillar. The light bulbs around the pictures create a kind of pyramid shape. The artist is saying that the photographs form a kind of structure to prevent the memories from being lost. They form a kind of house, a tomb or even a mausoleum of memory. As we look at the children's faces we step into that sacred place.

Do they always keep the light bulbs lit?

They have to stay on – if the light were to fade or flicker we wouldn't be able to see the faces and the work would disappear. The photographs could be lit from above but that would break the rhythm of the circles of light. It would also spoil the sense of the work, as it would no longer be self-contained. In synagogues and churches the light from candles or oil lamps has always symbolized the presence of God whose spirit lights up the darkness. Boltanski picks up on that symbolism replacing candles with light bulbs. His work is not religious in the traditional sense, but the permanence of the light is a symbol of life and hope.

What are the boxes for?

Boxes are made to put things in. They remind us that the world is full of mysteries. The three boxes here suggest that the work alone cannot reveal everything. Despite being small they also form the foundations of this structure. Archive boxes and biscuit tins, they might contain tiny finds, pretty souvenirs or sad secrets. But we will never know because they don't belong to us.

All the faces look similar

They look similar because almost all of the poses are the same and because they have been blown up very large, so the features are rather unclear. The little girl in the middle was perhaps older than the others, some are smiling and others are more serious. But from a distance – or perhaps seen with the perspective of time – the details are less important. Seen face-on, these pictures are all that remain – like the image of Christ on the shroud. They are the evidence that these children once existed. In its own way this work is saying that each of these faces is as sacred as life itself.

All those wires must be dangerous

It's not dangerous but it is true that all those wires hanging down the wall do seem a bit Heath Robinson. Modern regulations mean that you rarely see this kind of set up. The way the artist has used the wires is significant because it makes the link to a past era – even though it's in the recent past – the past of the artist's childhood. It may also be a means of suggesting, if not danger, then the fragility of life which can 'hang by a thread'.

◊◊◊

They look like lights around a bathroom mirror

Some mirrors have lights set into the frames – in bathrooms and also in theatre dressing rooms so the actors can see clearly to put on their make-up. But this piece is very far from theatre. It shows Jewish children who can no longer play. Sunken in dark circles their eyes seem very large and tired. It's as though the children have been waiting for something for a very long time. The photographs were taken in 1939 and found later by the artist. We have no way of knowing what happened to these particular children, whether they survived the holocaust or not, but their childhood has gone for ever.

It reminds me of a family tree

These children may have belonged to the same generation but the work suggests something else. It creates a family of strangers linked by wires instead of branches. The wire could hold them prisoner but it could also hold them together as a group, stopping the pictures from getting muddled up and lost. Each is in its place, each is equally important. Because this is a monument built around specific individuals, taking one away would be like removing a stone from a wall – the whole thing might crumble. Like a family tree, this work speaks of the past and the future. In the Bible, particularly in the Old Testament, genealogy is important as it creates a link to ancestors and both back and eventually forward to God himself. Boltanski's work recreates something of that holy dimension.

Why 'Odessa'?

The artist's grandfather came from Odessa in the Ukraine where there was a large Jewish population. By referring to Odessa, Boltanski, who was born in France, links this work to his own origins. In Odessa candles are lit each year in memory of the dead (at Jahrzeit) and are never allowed to go out. Though these children are strangers, Boltanski celebrates their memory as if they were his own family. They are his family. And ours too.

Does Christian Boltanski always use subjects from the past?

Yes. You could say that he works with history itself. The objects themselves are just symbols and the stuff of the past. Photos, filing boxes, clothes, each item recalls a time not so long ago and never further back than half a century. So the viewer can always recognize something that reminds them of their childhood. Boltanski's art reminds all of us that we are a part of history – not only the history of text books but the history you can smell and taste and touch when you rummage in an old drawer, the history that you wish you knew as you stare at the faces of strangers you somehow seem to remember, in photographs.

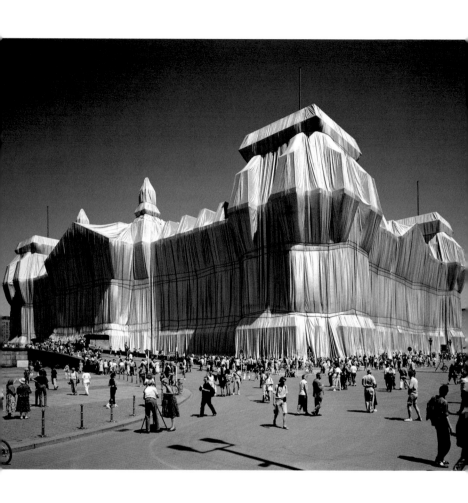

26 *Wrapped Reichstag*

Christo (born 1935) & Jeanne-Claude (1935–2009)
1971–95
Berlin

There must be roadworks going on

When certain buildings are being repaired parts of them might be hidden by hoardings but there's another reason here. This wrapped building is a work of art in the middle of a city, produced by two artists, Christo and Jeanne-Claude.

What's underneath?

It's the Reichstag – the building where the German parliament meets – in Berlin. Obviously it's quite hard to recognize when it's all covered up.

It's like a giant present

Yes, it's a present for the people of Berlin. As with all presents the wrapping is very important because it puts off the moment of discovery and allows you to wonder what's inside. It helps you dream. Sometimes when the paper is pretty we're careful not to rip it. Here the wrapping is silvery.

Why did they wrap up a building?

They did it because they wanted to do something different. People used to see the building every day and had almost forgotten that it was there. But suddenly they were able to see it in a different way. The Reichstag had always been naked and here it was clothed! People started looking at it as though it were new.

◊◊◊

How did they do it?

Christo and Jeanne-Claude conceived the idea for the work and designed the maquettes. Then they needed a huge team to make it a reality. 220 helpers rolled out the wrapping (100,000 square metres of silver polypropylene fabric) and 90 specialist climbers, who weren't afraid of heights, climbed all over the building to attach the wrapping with 8,000 metres of blue rope. It took a week to do.

Is it going to stay wrapped up forever?

No, in fact it's not wrapped up any more. The work only lasted for two weeks from 23 June to 6 July 1995. In the past, artists, architects, painters and sculptors used to hope that their work would last for centuries if possible. These days artists want to touch people in the here and now – it's ephemeral, like a conversation. The shorter the time a work is designed to last for, the larger the crowds that will flock to see it. It's all the more precious precisely because it won't last.

Can you wrap up anything you like in a city?

No. Public places are subject to particular legislation. So Christo and Jeanne-Claude had to seek the permission of the German state and MPs took a vote on whether they could go ahead. 292 voted for and 223 against. It took a lot of determination and perseverance on the part of the artists – all in all they had to wait twenty-five years for approval. But it doesn't always take that long. It only took about ten years to get the approval to wrap the Pont Neuf in Paris . . .

What happens when it's unwrapped?

When the wrapping comes off the building somehow seems to have something new about it. Like an actor trying on a new character it took on a new life for a short while. The fact that it was once wrapped up will now always be a part of its history and the history of the city. Whether or not they liked it, the people who witnessed it will never forget such a unique experience. For the Reichstag it was a doubly special moment because when the wrapping came down major modernization work began. So after being its being wrapped up the building did in fact change completely.

It's like the folds in a dress

Christo and Jeanne-Claude wrapped the Reichstag with draping fabric that in its own way recalled the clothing of antiquity. There it stood like a Greek statue in a kind of tunic or toga fluttering in the wind. The wrapping makes the shape seem somewhat compact but you can also make out the shapes of the columns in the folds. It's a way of bringing history to life. The Reichstag was built at the end of the nineteenth century, but thanks to this modern work it reconnected with the past and started breathing again.

◊◊◊

Why did they choose the Reichstag?

They chose it because it's famous. Its story is the story of twentieth-century Germany. Built for parliament at the end of the nineteenth century it was set on fire by the Nazis in 1933 and then suffered an attack by Russian soldiers at the fall of Berlin in 1945. It wasn't until reunification in 1990 that the federal parliament (Bundestag), which had been in Bonn, moved back to the Berlin building. So it's a very symbolic place for Germans and for the whole of Europe; a sign of unity rebuilt. Wrapping the Reichstag gave Christo and Jeanne-Claude their own little piece of history and also gave history back a bit of its youth because the wrapping they chose evoked the covers sculptors use to drape over

their projects when they are not working on them. The Reichstag regained some of the freshness of a work in progress.

Did Christo and Jeanne-Claude always work together?

Yes. Christo and Jeanne-Claude were an artist couple: Christo Vladimiroff Javacheff (who was a painter to start with) and Jeanne-Claude Denat de Guillebon. They met in 1958 and for a long time simply went by the single name 'Christo'. Their work was always a close collaboration. First they would discuss ideas together then Christo would produce all the designs. Then they would have to get hundreds of people involved to make their monumental projects reality. Jeanne-Claude not only played an important role in the ideation but also in the practical organization that these projects required.

You can't buy a work like that

No, you can't buy it because a work like that cannot be owned. Nor can you even count the number of people who come to see it in the same way that you would with an exhibition. Anyone can come along and have a look and, as the work is taking place in what's already a tourist spot, a huge number of people will see it. At a guess some five million people would have seen *Wrapped Reichstag*. So it was a work for a much larger audience than any usual museum piece or temporary exhibition. It was designed to be free and as open as the city itself. That is why the work was entirely financed by the artists themselves. They paid for it by selling their other works to collectors or large museums. No one commissioned it and no one bought it so it really kept its true independence.

Is this Land Art?

No. Land Art is the term given to installations in a landscape, usually somewhere very isolated. Christo and Jeanne-Claude's monument wrappings were always in urban contexts so they can't be divorced from social life and the way people move in a built environment. There were four 'wrappings' – prior to the Reichstag they had wrapped the Kunsthalle in Berne in 1968, the Museum of Contemporary Art in Chicago in 1969, and the Pont Neuf in Paris in 1985. But these were only a small part of Christo and Jeanne-Claude's oeuvre. They also created installations in natural environments that didn't involve any wrapping – including *Valley Curtain*, *Running Fence*, *Surrounded Island* and *The Umbrellas*. But there are some common themes – like the use of fabric, a light fragile material capable of transforming or redesigning places and objects. Generally speaking they preferred to refer to their work as 'environmental', underlining that its goal was to bring 'the joy of beauty'.

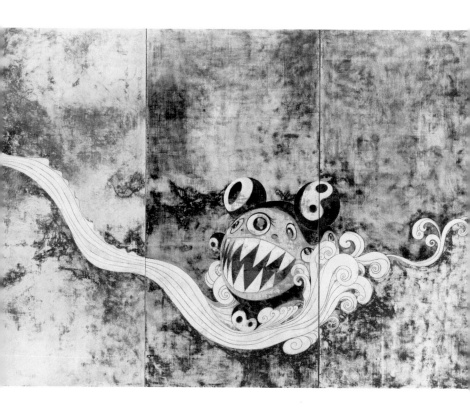

27 727

Takashi Murakami (born 1962)
1996
300 x 450 cm
Acrylic on canvas mounted on panels
Gift of David Teiger, Museum of Modern Art, New York, USA

It looks like Mickey Mouse

It has the same sort of head and large ears as Mickey Mouse but Mickey is American and this character is Japanese. He certainly doesn't want to be mistaken for Mickey. He's called Mr DOB: his left ear has a D on it and his right ear has a B, his mouth serves as the O, so you only have to look at him to read his name.

He's about to devour someone

Actually this isn't an evil character. He's thought of as *kawaii*, or 'cute' in Japanese. It's just that he shows his pointy teeth when he's excited, like he is here. He's playing in the sea and a big wave is lifting him up.

He looks like a Pokemon

Yes, he's a distant cousin of the Pokemon that appeared in video games in 1996 and he's about the same age. But he lives in a different world – the world of museum paintings and sculptures. This is one of the favourite characters of his creator Murakami. In fact Murakami liked him so much that he chose him as a kind of self-portrait, so you know that whenever you see Mr DOB it's actually the artist himself.

It's a large painting for such a small character

The work is made up of three panels so rather than being enclosed in a space that's only just big enough for him, Mr DOB can gambol about freely between them. It creates the impression of a landscape and makes the painting much more fun. You can dive in with him and get splashed by the waves.

◊◊◊

The wave is all curly

That's how the artist shows the water moving – the foam on the crest of the wave curling over on itself like a lock of hair. But this detail also evokes the very famous painting by one of Japan's most famous artists, Hokusai (1760–1849). It's a bit like adding a quote that everyone understands because the great master's wave *The Great Wave off Kanagawa* is just as well known by Westerners. Murakami pays homage to his country's tradition in a language that's universally understood.

The background is hazy

The figure and the wave are as precisely drawn as they would be in a cartoon but the background is a mass of floating colours – an effect created by rubbing acrylic paint with sand. Murakami uses it to suggest a breath of wind, the shape of the clouds and the mist in the distance that is typical in traditional Chinese paintings. So he shows that though Mr DOB is a modern character (born in 1992) he belongs to the very ancient world of Far Eastern art which we know from precious screens and silks. On the other hand, picking him out so clearly against the background underlines what an independent character he is. Mr DOB doesn't get mixed up in what's going on around him, he doesn't let other people influence him and he goes wherever he pleases.

Why is he called Mr DOB?

It's a joke. In the beginning DOB was the contraction of the Japanese expression 'Dobojite Dobojite' (Why? Why?), which keeps being repeated in the manga comic *Inakppe Taisho*, mixed up with the word *oshamunabe*, the catchphrase of comedian Toru Yuri. The artist used the new word in a number of works and then decided to create a new character. Like the artist, Mr DOB never stops asking the same question, he's curious, dissatisfied and un-submissive.

You don't often see characters like this in paintings

This character doesn't belong to any traditional form of painting either from the Far East or the West. Murakami invented this newcomer after being inspired by several characters in manga (Japanese cartoons), anime (animated films) and video games, including Doraemon, a robot cat, and Sonic the Hedgehog. Murakami also had in mind Cheburashka, the Russian character, and of course Mickey Mouse . . . Mr DOB has a large family.

What does the number 727 mean?

This number is the name of a Japanese cosmetics brand so the artist is linking his painting with advertizing – the images that everyone sees in the street, in magazines or on television. By evoking make-up Murakami speaks of transforming reality. It's also the number of a Boeing aircraft famous for its level of technical quality. The first Boeing flight took place in 1963 so it's a symbol of Murakami's generation and of an international dimension.

◊◊◊

Is Murakami's work like manga?

Their aesthetics are linked in as much as Murakami uses manga as a foundation for his work. He also uses similar methods of production (computer generation, industrial-style production, quality control and lots of assistants) and he also uses manga characters, their graphic quality and their 'flat' colours. But it's not a question of imitation. Though he draws on the rich sources of the visual culture he shares with all his contemporaries, at the same time he tries to draw attention to the picture of the world that manga conveys – smooth and shiny, highly detailed and peopled by robots and solitary children. Murakami studied traditional art at Tokyo University of Arts and initially wanted to enter the anime design industry. But instead of that he brought manga to museums and with it a reflection about the nature of Japanese society today.

What's this style of painting called?

It's sometimes called Neo-Pop which makes a link to the work of Andy Warhol, the central figure of Pop Art in America. Murakami has also used names like Tokyo Pop or Poku which combines 'pop' and 'Otaku'. 'Otaku' culture is a world in itself and is a big trend in Japan as it groups together producers and fans of manga, video games, anime and figurines. By using terms like this Murakami is stressing the specifically Japanese character of his art which he doesn't want to be seen as either a subgenre of something American or as something 'exotic'. But the more international term Superflat is also very popular because it describes both the way the work (painting or sculpture) looks and a desire to 'flatten' things by mixing up references without any respect for hierarchy.

Why was Murakami's work shown at the Chateau of Versailles?

The Chateau of Versailles is one of the most frequently visited museums in the world, so it's an ideal place to introduce a contemporary artist's work to a large audience – even if it's by surprise. The East-meets-West context may have shocked some but it shouldn't allow people to underestimate Murakami's intellectual and technical sophistication. Like the artists who painted mythological scenes in the seventeenth century he layers religious, historical and literary references. Whilst appearing very straightforward the works are reflections on power and war, which is very relevant in the surroundings of Versailles. As a child Murakami had discovered Versailles thanks to a famous manga *The Rose of Versailles* by Riyoko Ikeda produced in 1972.

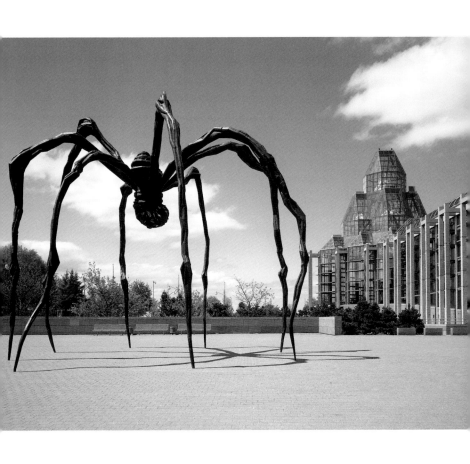

28 *Mum*

Louise Bourgeois (1911–2010)
1999, cast in 2003
Bronze, stainless steel and marble
927 x 891 x 1024 cm
National Gallery of Canada, Ottawa, Canada

It's scary

That's particularly because it's giant-sized. But this bronze spider isn't doing anything threatening – it's not her fault.

It looks as though the spider is walking

She's not moving at all. But if you are afraid of spiders you might start imagining that she's scuttling along. Her long legs give the impression that she's capable of movement.

She's got eight legs

With spiders it's always the legs you notice first. They are so fast and agile that they give the impression of having dozens of them when actually it's only eight. Louise Bourgeois wanted to sculpt a spider that was realistic but this wasn't a detailed representation.

They've put it outside

Many sculptures are displayed outside – particularly very large ones. Many people never go to museums because they don't have the time or don't think they'll like it. For them this piece of art is there and they get to see it anyway. They get used to it so it becomes a part of their lives just like the landscape or the roads.

◊◊◊

This spider is the size of a house

Louise Bourgeois sculpted it so large so that we could understand how important this figure was for her. It's like what they used to do in mediaeval paintings where certain characters appear larger than trees . . . The size of things corresponds to their significance in the story so there is no way to confuse what is central with what is incidental. Here the spider is alone but the size gives an indication of the intense emotion it represents for the artist; a mixture of fear – spiders are often shown extra-large in horror films – and security, because the body forms a shelter.

She hasn't got a web

Not all spiders spin webs. Some simply chase and catch their prey. Maybe that's the case with this one here but that doesn't make it feel any less worrying. But on the other hand not being a web-spinner makes this spider seem rather solitary

– almost fragile. She's out in the open rather than dominating the scene from the centre of her web. In a different piece, the artist also evoked the spider's work (*Spider*, 1997) by placing fragments of tapestry in a cylindrical cage.

Mum is a very surprising name for a spider

The spider evokes the artist's mother who worked with tapestries. As a child Louise Bourgeois would watch her work in her workshop 'As intelligent, patient, clean and useful, reasonable, indispensable, as a spider,' as she wrote later. The choice of title, *Mum*, is important because it's about recreating how she saw her mother when she was little. She doesn't just want to describe it so it's not called 'My Mum' and certainly not 'My Mother'. Rather 'Mum', a name pronounced with affection. Thanks to this sculpture Louise Bourgeois speaks not only *about* her but *to* her.

There's lots of empty space in this sculpture

That's a feature in modern sculpture – it's interested as much in the spaces, holes and gaps as it is in the shapes. Space presented an additional challenge for the sculptor who had to balance this spider and make sure it would stand up. But it also creates a new relationship between the subject and the world around it. The landscape appears between its legs as though dissected by them. The work is no longer simply an object set apart, but a design in a space, a filter through which we see reality.

Can you walk under it?

Yes you can. Passers-by walk between the feet. They end up forgetting that it's a giant spider and it becomes like a piece of architecture for them: the legs are like columns and the spaces are like doors. Most sculptures are made to be looked at from a distance, but not this one. This one makes the person walking beneath it a part of the work itself. They become a moving part of the work, but you could also imagine them as prey.

◊◊◊

She could have sculpted a real portrait

A real portrait would have been completely personal. A classic portrait assumes the artist is aiming to capture some kind of likeness – even if it is stylized – so it would have reproduced to some degree the individual's features or expression. But Louise Bourgeois preferred this figure which is impossible to identify and so takes on a more general nature that can touch anybody. Faced with this spider

you can't think 'It's Mrs X, the artist's mother – someone else's mother'. She wanted us simply to think 'Mum', as if thinking of our own mother.

What did Louise Bourgeois's mother think of this piece?

Her mother died when she was only twenty-one. So her mother never knew about this spider that appeared some sixty years later and it's hard to imagine what her reaction would have been. Most often portraits are produced at the request of the model or at least with their agreement but this is different. This is an evocation of the deepest, most personal memories but designed with the benefit of distance and maturity. By creating this sculpture the artist reveals as much about herself as about her mother. The work gives form and voice to buried feelings, unspoken words, letting unformulated thoughts and even secret suffering come flooding back. It must have taken a long time before she could allow those things to the surface.

Are there other spiders in art?

In old fashioned scenes spiders represented poor housekeeping. But all alone they have a more menacing appearance – like in the work of Odilon Redon, an artist who belonged to the Symbolist generation. But it's the spider's ability to spin webs that is most often the focus. In traditional paintings a woman holding a spider's web might for example be an allegory for Industry, meaning the professions, knowledge and ingenuity. By focusing on the spider and not on the web, Louise Bourgeois pays homage to the person through her own personal feelings that are lent depth by the context of mythology. According to legend the spider was created from the metamorphosis of a weaver who defied Athena. To punish Arachne's impudence the goddess condemns her to spin forever and so the spider was born. In human form another bronze spider sculpted by Germaine Richier (1902–59) just after the war expressed the pain of that curse. Louise Bourgeois's spider absorbs all of that into its monumental dignity.

Why is this piece so well-known?

Louise Bourgeois produced a number of sculptures entitled *Spider* and all of them are a meditation on the role of women in the family and in society but this one became emblematic of the whole of her work. The very particular title, *Mum*, reveals the autobiographical nature of all her work – an essential element in modern art. All over the world you can see this solitary outline against the sky; a familiar creature which in this form has become the artist's signature.

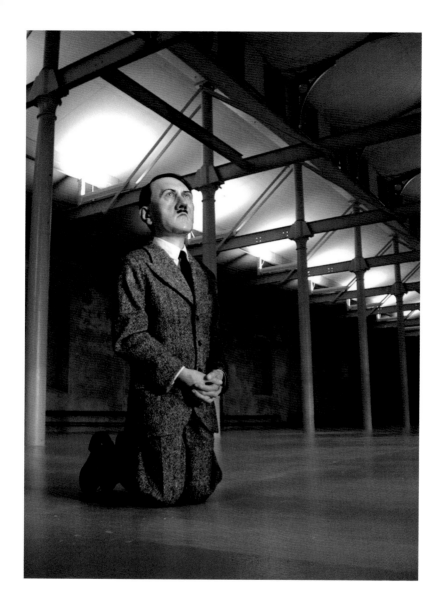

29 *Him*

Maurizio Cattelan (born 1960)
2001
Wax, human hair, clothing, polyester resin
101 x 41 x 53 cm

It looks like a real person

The sculptor wants us to think it's a real person. When you approach a statue in a museum you know that it's a special object. But this figure was conceived so that we would think it was a person like us – when in fact it is nothing of the sort.

It's a little boy

This figure is the size of a small boy but it's actually an adult produced in small scale. It's disconcerting. The large shoes are adult style shoes but they seem disproportionate to the body, there's something not quite right. Maybe the sculptor did that to warn us . . . This is not what it seems.

What is he doing?

He's on his knees with his hands linked and he is looking to the sky so we assume he is praying, but we don't know anything more than that. The position of the body gives us an idea but it doesn't necessarily tell us what he's thinking.

In this photo you can see his face but in the museum he has his back to us

Having his back turned makes him appear much more like a human than a statue, because normally statues face their public. Either this man is not interested in anyone or he has turned his back on us.

◊◊◊

It's a statue wearing clothes

This waxwork is wearing real clothes – it's much simpler than imitating clothing. It's a very old way of making a statue appear more human, closer to a real person. In Spain for example statues of the Virgin and of Christ have long been dressed in real clothes on festival days and for processions. What's more the artist has chosen a simple suit. *Him* is clothed just like anyone else. In a group he would pass unnoticed.

Why not have the face visible from the start?

The face isn't visible from the start so that it's a surprise when you see it. You approach out of simple curiosity without any concerns. The way the work is presented is essential – even if photographs allow us to see it face on, that's not necessarily the case when it is displayed in a museum or exhibition. You have to

go up to him, walk around him and only then do you see his face. It's a shock when you recognize him because nothing about the figure would have prepared you for who it is.

So who is it?
It's Adolf Hitler. He was the German head of state from 1933 to 1945. He was responsible for having hundreds of thousands of innocent people, particularly Jewish people, deported, imprisoned, tortured and killed in what became known as 'death camps'. When he realized that Germany would be defeated at the end of the Second World War he killed himself. He represents the negation of all human values, absolute racism, hatred and cruelty.

He has a little Charlie Chaplin moustache
That was the fashion at the time but nowadays the little moustache appears rather comical. Charlie Chaplin's moustache was almost identical. In fact in the film *The Dictator* (1940) he played the double role of Hitler and a poor Jewish barber who resembles Hitler so closely that the two get mistaken for one another. In itself the moustache has no particular meaning but it can give rise to totally opposite emotions. What is touching and sweet for one is threatening in the other.

It looks like a waxwork from Madame Tussaud's
It's the same idea – making something look as real as possible. The figures in Madame Tussaud's in London have wax faces and resin bodies and they also have real hair. But those waxworks are usually in a typical scene from their lives demonstrating who they are; Jean-Paul Marat dead in his bathtub or Michael Jackson singing. This statue of Hitler isn't to glorify him and refuses to celebrate what he was. That is why he is in a position quite foreign to what we know of him.

Don't artists usually make statues of people they admire?
That's right, and that's why there are no statues of Hitler to be found in towns or in museums. But art can also remind us to be vigilant, show us what to be wary of and that's why you would see images of the devil and hell in old paintings. To look at this man is not to honour him but to remember the atrocities he committed. With his blank expression he could also be likened to an image of death – it recalls the funeral masks which inspired the waxwork museums. Madame Tussaud, who opened the first waxworks in London in 1835, had started her carrier in Paris moulding the dead faces of French revolutionary heroes.

◊◊◊

Why is he the size of a child but with an adult's face?

No doubt there are several reasons. The artist may have used scale to suggest an impossibility – the reconciliation of the innocence of childhood with absolute criminality. It's impossible to imagine Hitler's face as a child. It also poses the question of why and at what point a human can become capable of such terrible barbarity. Combining an adult head with a child's body may also evoke the indoctrination that occurred with the Nazi's enrolling very young children. To create real killing machines the children were led to believe, say and do things that children ought never to have been involved with. It's a practice that still goes on today elsewhere in the world. So Cattelan is simply reminding us that this is no 'great' man.

Why isn't Hitler's name in the title?

'Him' is what we say when we point at someone. So the name in itself is a kind of accusation. But there is more to it than that. In the Old Testament it was forbidden to speak the name of God because He is by definition unknowable by His creatures. *Him* is not God but he acted as though he were and as though he held the power of life and death over others. On the other hand, in the book of Genesis God gives Adam the task of naming his creatures. Naming something is a very fundamental act that essentially means recognizing its existence among others. Cattelan's model is excluded from the community of mankind by being deprived of a name. Even without knowing these references you can immediately get the sense from this title that the subject is unspeakable.

Why does Cattelan show him praying?

It may be the most sober way of creating a contemporary image of hell. Maurizio Cattelan choses the opposite route to the German artist George Grosz (1893–1959) who painted Hitler assaulted in the furnace by the shadows of his victims (*Cain, or Hitler in Hell*, 1944). Cattelan shows a small man in short trousers, shoes polished and neatly tied as though nothing at all were wrong – utterly inoffensive . . . Then like any artist, he tells a story: he puts Hitler on his knees and condemns him to remain in penitence forever.

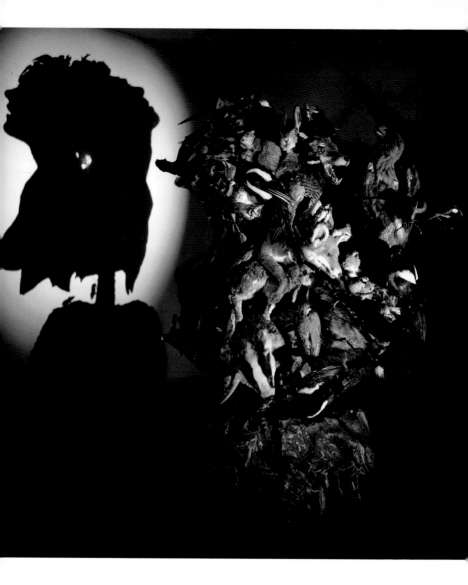

30 *British Wildlife*

Tim Noble (born 1966) & Sue Webster (born 1967)
2000
88 stuffed animals, projector
150 x 90 x 180 cm

Are they real animals?

Yes, they are real animals but they have been stuffed. Once they were dead, their bodies were conserved using chemicals. These animals have their own fur and their own feathers. There are eighty-eight of them in all: foxes, birds and hares. The artists only used animals that are hunted – or 'game' – not farm animals or pets.

It looks like they are having a fight

It's unlikely that all these animals could be gathered so close together in real life without there being some fights. The only way they would be in the same place at the same time is if they were in a picture of heaven where all the animals – foxes, birds of prey or rabbits – lived in harmony with one another.

There are people on the wall

The shadows of a man and a woman are thrown on to the wall behind the animals. They are Tim Noble and Sue Webster, the artists. Though they have their backs to one another they seem to be joined together. Their faces are lifted upwards and it looks like they are waiting for something.

The woman is naked

This work is all about nature in its wild state so clothes seem unnecessary. Both the people are naked, just like the animals.

◊◊◊

Who killed the animals?

The artists didn't kill them, but Tim Noble's father, who is a huntsman, did. When he died Tim Noble inherited this collection of stuffed game and decided to create this piece as a tribute to his father. That's why this is called *British Wildlife*, recalling both the father's favourite pastime and the British love of nature.

Why are the animals all piled on top of each other?

They take up less space this way. Of course they could have been mounted on a wall or displayed in rows as they would have been traditionally, but you'd need lots of space for forty-six birds, forty mammals and two fish side by side. However, the magpie, the tits, the badger, foxes, swan and crow are all part of

Tim Noble's childhood memories. He can't have wanted these old companions to be seen as simple hunting trophies. Piled up like this they create a single image, a summary of the past.

Where are Tim and Sue?

They're not there at all. When you see their shadows on the wall it seems as though they must be very close by so you try and find them. But in fact it's the pile of animals lit by a projector that throws their silhouette on to the wall. Even when you know that's the case it's hard to believe because there's no apparent link between the two things. Normally people's shadows follow them around but Tim's and Sue's have taken on a life of their own.

Is this a still life?

This piece does recall the 'return from hunting' still life paintings full of animals. But this takes the subject into a third dimension. The traditional still life paintings developed from the seventeenth century onwards tended to stand alone as pictures with a whole set-up that establishes the central theme – the relationship between the objects and the figures. But for this work the still life is only one element.

You can see stuffed animals in natural history museums

The stuffed animals displayed in natural history museums will have been treated by a specialist taxidermist just like these. But the artists here are not motivated by anything scientific; they aren't aiming to introduce a particular species or explain anything about how the animals live. This installation is designed to cause surprise, emotion and even to suggest that there is nothing 'natural' about it.

◊◊◊

It reminds me of Arcimboldo's work

Arcimboldo became famous in the sixteenth century for his '*bizarreries*', portraits using only fruits and flowers. Tim Noble and Sue Wesbter follow in that seductive tradition, playfully leading the viewer to contemplate fairly serious subject matter; the difference between appearance and reality, the contradiction between the single items we accumulate and the effect they produce and so on. Here, they use only animals yet portray a human couple, so depending on your perspective you might say this is a collection of animals or a double portrait. Both points of view are right – the work reminds us that no-one has a monopoly on the truth.

It's like a shadow puppet

Yes, it's a bit like making a duck or a rabbit with your hands – but much more complicated. Everyday objects and gestures have become the stock in trade of artists, but we can also look at this work on a much more complex level because it picks up the ancient themes of the cave allegory from *The Republic* by Plato (428–348 BC). The philosopher Plato explains that men are like prisoners chained up in a cave with their backs to the entrance. All they can see of the world is the shadows thrown on to the back wall of the cave. As humans, we are prisoners of our senses and our view of the world is not truth, but an illusion. *British Wildlife* plays with the same theme by presenting side by side the real group of animals and the illusion of the couple we think we can see. As an installation it makes us question the extent to which we allow ourselves to be deceived by appearances.

Do these artists always use animals?

No they don't always use animals. They originally worked with rubbish – things people had thrown away and bits of old paper. But they always aim for a similar effect to what is achieved here by the shadows of the two artists bearing no resemblance to the collection displayed. They started working with animals thanks to Tim Noble's mother's cats which would bring their dead prey into the house. Tim Noble and Sue Webster collected these little trophies and soon had dozens of specimens which they displayed in a box labelled *Dead Things*. Inspired by the mummies and animal statues at the British Museum they began to incorporate their own little 'mummies' into their work. Whilst everyday life provided the foundations, ancient art was a catalyst for them.

So what does the link between the animals and the couple mean?

It could be a symbol of the eternal link between animals and people – of the beast within all humans or the humanity present in animals. But the way the couple are back to back, and the tension that suggests also evokes ancient depictions of Adam and Eve; perhaps they represent the couple driven out of the Garden of Eden. It's the beginning of human history with its lot of suffering, love and death. Other ancient texts link the birth of drawing as an artform to the outline of a shadow, sketched by a young girl to capture the likeness of her beloved. *British Wildlife* is also a celebration of art's origins 'signed' with a double self-portrait.

Resources

If you want to know more there are many books on modern and contemporary art available. It's impossible to provide an exhaustive list, so we have highlighted a few main references as a starting point.

Artists' perspectives and interviews

Joseph Beuys, *What is Art?: Conversations with Joseph Beuys*, Clairview Books, 2007

Patricia Bickers and Andrew Wilson (eds.), *Talking Art: Interviews with Artists since 1976*, Ridinghouse, 2007

Brassaï, *Conversations with Picasso*, University of Chicago Press, 2003

Salvador Dalí, *The Secret Life of Salvador Dalí*, Kessinger Publishing, 2010

Marcel Duchamp, *The Writings of Marcel Dunchamp*, Da Capo Press, 1989

Jack D. Flam, *Matisse on Art*, University of Chicago Press, 1994

Vassily Kandinsky, *Kandinsky: Complete Writings on Art*, Da Capo Press, 1994

David Sylvester, *Interviews with Francis Bacon*, Thames & Hudson, 1987

Andy Warhol, *The Philosophy of Andy Warhol: From A to B and Back Again*, Penguin Classics, 2007

General works

Françoise Barbe-Gall, *How to Talk to Children About Art*, Frances Lincoln, 2005

Françoise Barbe-Gall, *How to Look at a Painting*, Frances Lincoln, 2011

John Berger, *Ways of Seeing*, Penguin, 1990

Matthew Collings, *This is Modern Art*, Phoenix, 2000

Stephen Farthing and Richard Cork, *Art: The Whole Story*, Thames & Hudson, 2010

Hal Foster and Rosalind Krauss, *Art Since 1900: Modernism, Antimodernism and Postmodernism*, Thames & Hudson, 2004

E. H. Gombrich, *The Story of Art*, Phaidon, 1995

Charles Harrison and Paul Wood (eds.), *Art in Theory 1900–2000: An Anthology of Changing Ideas*, Wiley-Blackwell, 2002

Robert Hughes, *The Shock of the New*, Thames & Hudson, 1991

Norbert Lynton, *The Story of Modern Art*, Phaidon, 1989

Exhibition catalogues

The catalogues which accompany large single artist exhibitions are very informative. You might also take a look at thematic exhibition catalogues; particularly enlightening because they put twentieth-century art in the context of preceding centuries. Examples include:

Cornelia H. Butler and Catherine de Zegher, *On Line: Drawing through the Twentieth Century*, MoMA Publications, 2010

Iria Candela, *Miro*, Tate Publishing, 2011

John Elderfield, *de Kooning: A Retrospective*, MoMA Publications, 2011

Gladys Fabre and Doris Wintgens Hötte (eds.), *Van Doesburg and the International Avant-Garde: Constructing a New World*, Tate Publishing, 2010

Christoph Grunenberg, *Rene Magritte: A to Z*, Tate Publishing, 2011

Norman Rosenthal and Richard Stone, *Sensation: Young British Artists from the Saatchi Collection*, Thames & Hudson, 1998

Museum websites

Any search engine will take you to these gold-standard sites. The following websites are a good place to start:

www.tate.org.uk and the junior version, which is specifically designed for children http://kids.tate.org.uk

www.moma.org

http://www.centrepompidou.fr/ and the junior version http://junior.centrepompidou.fr/

For a general approach take a look at the network of public modern and contemporary art collections at:

www.culture24.org.uk

Artists' official websites

It's not always the case but some artists have their own dedicated websites. Search their name and you will often find all sorts of interviews available online. Even if they are very short they are often a valuable way of getting to know an artist's work better.

Picture credits

Luisa Ricciarini / Leemage: pp. 54, 70, 78, 82

DACS / Les Héritiers Matisse / The Bridgeman Art Library: p. 62

akg-images: pp. 58, 80, 134, 138

Dist. RMN / Adam Rzepka: p. 66

Collection Centre Pompidou, Dist. RMN / Philippe Migeat: pp. 122, 142

Collection Centre Pompidou, Dist. RMN / Droits réservés: pp. 106, 118

RMN / René-Gabriel Ojéda: p. 74

The Bridgeman Art Library: pp. 102, 126

Tate Gallery, London 2011: p. 114, cover

Courtesy Sean Kelly Gallery, New York: p. 130

Wolfgang Volz / LAIF-REA: p. 154

MBAC: p. 162

Digital image, The Museum of Modern Art, New York, 2011 / Scala, Florence: p. 158

Albright Knox Art Gallery 2011 / Art Resource, New York / Scala, Florence: p. 98

Oronoz / Fotografia digital, Madrid: p. 94

Collection particulière / Droits réservés: p. 86

Hirshhorn Museum and Sculpture Garden, Smithsonian Institute
/ Photography by Lee Stalsworth: p. 110

© ADAGP, Paris 2011: pp. 58, 66, 70, 78, 82, 86, 106, 118, 122, 150, 162

© ADAGP, Paris 2011 / CNAP / Droits réservés: p. 146

© The George and Helen Segal Foundation / ADAGP, Paris 2011: p. 110

© The Andy Warhol Foundation for the Visual Arts, Inc. / ADAGP, Paris 2011: p. 134

© Robert Rauschenberg / ADAGP, Paris 2011: p. 102

© Foundation Antoni Tàpies, Barcelona / ADAGP, Paris 2011: p. 94

© The Willem De Kooning Foundation / ADAGP, Paris 2011: p. 90

© Courtesy of the artist and Galerie Emmanuel Perrotin: p. 166

© Tim Noble & Sue Webster / Courtesy Gagosian Gallery: p.170

© Wolfgang Laïb / Courtesy Sean Kelly Gallery, New York: p. 130

© Jana Sterbak: p. 142

© Succession Picasso: p.74

© David Hockney: p. 114, cover

© Jeff Koons: p. 138

© Courtesy Christian Boltanski: p. 150